HOCKEY
IN SEATTLE

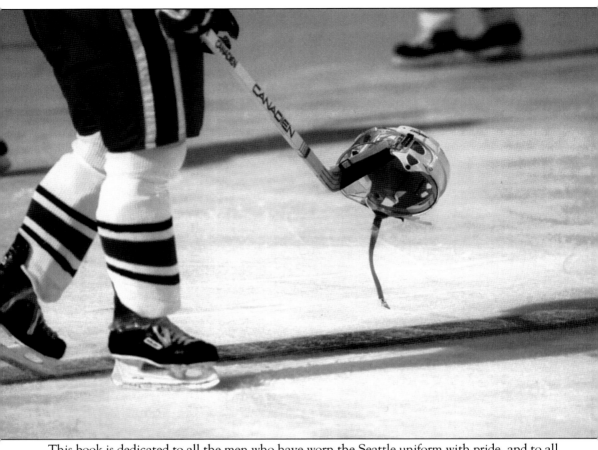

This book is dedicated to all the men who have worn the Seattle uniform with pride, and to all the fans who have supported them.

HOCKEY
IN SEATTLE

Jeff Obermeyer

ARCADIA
PUBLISHING

Published by Arcadia Publishing
Charleston, South Carolina

Printed in the United States of America

Library of Congress Control Number: 2004110488

For all general information, please contact Arcadia Publishing:
Telephone 843-853-2070
Fax 843-853-0044
E-mail sales@arcadiapublishing.com
For customer service and orders:
Toll-Free 1-888-313-2665

Visit us on the Internet at www.arcadiapublishing.com

CONTENTS

ACKNOWLEDGMENTS

No book of this scope can be completed without the assistance of a number of people. First and foremost I would like to thank my friend and fellow collector, Dave Eskenazi, who not only put me in touch with Arcadia Publishing but also gave me carte blanche to utilize his amazing collection of Seattle hockey memorabilia. Without his contribution, the earliest chapters of this book would not be as complete.

Thanks are also due to the other people who provided many of the images you are about to see. Carolyn Marr at the Museum of History & Industry (MOHAI) in Seattle was extremely helpful in finding photos for me in the museum's library, as well as having prints made from original negatives. I relied heavily on photos from MOHAI in the early chapters of the book, and without their assistance this project would have been dead in the water. Thank you also to long-time Seattle hockey follower Johnnie Jones and to the family of the late Gord Hemmerling who were so generous in providing me with photos.

The Seattle Thunderbirds Hockey Club has enthusiastically supported this project since day one. John Davis (Director of Public & Media Relations) was on board from the start, as were Colin Campbell (Assistant General Manager and Director of Marketing) and Rick Ronish (Director of Operations). They gave me access to their entire photo archive and were of great help in obtaining approvals when necessary. Thanks also to their photographer Harry Conrad, who took a number of the photos included in the chapter on the Breakers and Thunderbirds.

I have been fortunate enough to meet and speak to a number of former players who skated for the Totems, and all have been very generous with their time: Howie Hughes, Don Ward, Guyle Fielder, Val Fonteyne, Bev Bentley, Lionel Repka, Norm Lenardon, Jim Powers and Vince Abbey, to name a few. Bill MacFarland in particular has been supportive of this project, and his Foreword is a wonderful addition to the book.

My friend Louis Chirillo was a big help to me as a proofreader, and his web site on the Seattle Totems (www.seattletotems.org) is one of my favorite spots on the web.

Ralph Riddle first introduced me to the history of hockey in Seattle with his stories of watching the Totems, and his childhood keepsakes were the first pieces of my hockey memorabilia collection.

A quick word of thanks also to my friends and fellow Thunderbirds season ticket holders in Section 113—Gail & Porter, Bonnie & Scott, Ron & Marilyn, Ryan & Kami, Jim, Fred, Mike and Paul. We've had some great times together, and you were always willing to listen to me ramble on about obscure Seattle hockey trivia.

Finally, thanks to Holly—my wife of 10 years. You've been by my side in life and at hockey games for a long time, hopefully with many more to come.

FOREWORD

The story of professional hockey in Seattle is part sports and entertainment, part business, and part litigation. I was privileged for 15 years, from 1957 until 1972, to participate in all parts of the story with the Seattle Totems as a player, coach, general manager, part owner, and as the president and legal counsel of the Western Hockey League. This book by Jeff Obermeyer, through pictures and prose, deals with the best part of the history—the sports and entertainment—the players, the games, the championships won, the statistics and the records established.

The one constant in my hockey experience is that at every level I came in contact with hundreds of good people dedicated to the sport, many of whom I consider mentors as well as friends. They all contributed, in one way or the other, to the history of professional hockey in Seattle. Particularly my Seattle teammates: Rudy Filion, my road trip roommate for five years, who introduced me to coffee; Guyle Fielder, an amazing hockey player and a good friend; Aggie Kukulowicz, who later traveled as the translator for the Russian hockey teams, who showed me Moscow at night in 1972; Hank Bassen, who shared a house with me my first year in Seattle when our wives were left at home to have our first born; Noel Picard, who always kept the dressing room loose; and Bev Bentley, Don Head, Gerry Leonard, Frank Arnett, Don Chiupka, Marc Boileau, Jim Hay, Chuck Holmes, Jim Powers, Bill Dineen, Don Ward, Howie Hughes, Larry Lund, Larry Hale, Les Hunt, Bobby Schmautz, and Tommy McVie; Pat Quinn and Jerry Meehan, who became NHL coaches and executives; Murray Costello, who became president of the Canadian Amateur Hockey Association, and all the others standing with me in the team pictures in this book. There are anecdotes associated with all of them—some can be published, and some cannot; in any event, too many stories to mention here.

One cannot reflect on hockey history in Seattle without paying special tribute to Vince Abbey, the man most dedicated to the perpetuation of professional hockey in Seattle in my time, and George A. ("Al") Leader. Al Leader was a sixteen year old playing junior hockey in Watson, Saskatchewan when the Seattle Metropolitans won the Stanley Cup in 1917, and that is about the only significant event in Seattle's professional hockey history that he did not influence.

No one in the history of the Western Hockey League dominated at ice level like Al Leader's nephew—Guyle Abner Fielder. In 1957, I was sent to Seattle to replace Guyle, who had been recalled by the Detroit Red Wings. I was given his locker, his uniform number 7, and his center ice position between Val Fonteyne and Ray Kinasewich. Unfortunately I was not given his ability. Later in the season Guyle came back to Seattle, reclaimed his locker, his uniform number, and his center ice position. I was relegated a smaller locker by the men's room, assigned number 15, shifted to left wing on Rudy Filion's line. . . . And the rest is part of the history described in this book.

Bill MacFarland
May 2004

7

INTRODUCTION

Ask a local hockey fan about the history of the game in Seattle and the most you will usually get is something about the Metropolitans winning the Stanley Cup, and maybe some vague reference to the Totems. Even the older fans can't tell you much more than this. Sure, they remember the Totems and some of the star players of the 1960s and 70s, but ask about what happened before the Totems and you'll receive nothing more than a blank stare.

Seattle has lost touch with its hockey roots, which is too bad considering what a long and interesting history the sport has in the city. Hockey has been played almost continuously in Seattle since 1915, with a mix of professional, high-level amateur and junior league teams taking to the ice. Of the roughly 1,000 or so players who have suited up with the city's highest level teams, about 250 appeared in at least one game in the NHL and eight have been inducted into the Hockey Hall of Fame: Keith Allen, Emile Francis, Frank Foyston, Harry Holmes, Al Leader, Lester Patrick, Lloyd Turner and Jack Walker.

Part of the reason for the lack of knowledge is due to the absence of an NHL team in Seattle. The story of the city's quest for an NHL franchise could fill a book in its own right, full of intrigue, back-room deals, broken promises, and even an anti-trust lawsuit filed against the league by the Totems. The additional fan and media attention surrounding an NHL team would increase interest Seattle's hockey heritage, but based on the state of the game today and the lack of a suitable venue in the city, that remains a dream for another day.

I have followed hockey in Seattle for many seasons, through all of the ups and downs, successes and failures. Hockey has given me so many great memories over the years, and it has introduced me to a number of people who became some of my closest friends. *Hockey in Seattle* is my way of giving something back to the game that has brought me so much joy. Understanding the game's history can only increase interest in the sport, and that's something that benefits us all. To know hockey is to love it, and I hope that you will know hockey in Seattle a little better after seeing the pictures and reading the stories that follow.

Jeff Obermeyer
May 2004

ONE

The Metropolitans (1915–1924)

There was electricity in the air as the fans filed into the Seattle Arena on the evening of March 26, 1917. The fourth game of the Stanley Cup finals between the Montreal Canadiens and the hometown Metropolitans was about to get underway, and a victory would clinch the series for the locals. Bernie Morris opened the scoring for the Mets with a goal 1:56 into the first period, and from then on it was all Seattle as Morris scored six times to lead the club to a 9-1 decision over the defending champs. The Seattle Metropolitans had become the first team based in the United States to win the vaunted Stanley Cup since it was first awarded in 1893, and they did it in only their second year of existence.

The Mets were established in 1915, joining the four-team Pacific Coast Hockey Association (PCHA) founded by brothers Frank and Lester Patrick four years earlier. To ensure a suitable ice surface would always be available in Seattle's temperate climate, the Seattle Arena was constructed that summer. Located at the corner of Fifth Avenue and University Street, the new arena was a state of the art multi-purpose facility with an artificial ice plant, one of less than a dozen like it in North America. The ice plant allowed hockey or ice-skating year round, and a suspended floor could support other events such as track meets or the circus. With the arena in place, all that remained was for the team to acquire some players. The club looked east, to the rival National Hockey Association (NHA) operating in Quebec and Ontario. Frank Patrick orchestrated a raid on the Toronto Blueshirts franchise, signing six of its players to contracts to play in the PCHA. Five of them, including future Hockey Hall of Famers Frank Foyston, Jack Walker and Harry Holmes, would form the nucleus of the Metropolitans for years to come. Pete Muldoon, a former professional boxer and lacrosse player, was hired to manage the club. The team's colors were red, white and green, and the jersey crest was a large letter "S" with the letters "S-E-A-T-T-L-E" inside of it.

After a respectable 9-9 inaugural season, the Mets improved to 16-8 in 1916–1917 and were the top club in the PCHA. By virtue of their first place finish they earned the right to host the NHA champion Montreal Canadiens for the Stanley Cup, emblematic of the top hockey team in North America. The Mets defeated Montreal in the best-of-five series behind the amazing

offensive performance of Bernie Morris, who scored 14 goals in the four games played. The Mets again hosted the Canadiens for the Stanley Cup two years later in 1919, but this time with a much different result. The two clubs battled to a stalemate through the first five games of the series, including a scoreless overtime tie in the fourth game, and a number of players on both sides were injured as the physical play took its toll. The deciding game was scheduled for April 1, but was postponed when a number of the Canadiens came down with the flu prior to the contest, part of an epidemic sweeping the globe in the wake of World War I. When the condition of the players did not improve, the series was cancelled by local heath officials. It was the only time in its history that the Stanley Cup was not awarded. Joe Hall of the Canadiens never recovered from his illness and died of pneumonia in a Seattle hospital on April 5.

The Mets played for the Stanley Cup again the following year, this time making the long trek east to face the Ottawa Senators. They lost the series three games to two and never again competed for the Cup. The team went into decline following the 1920 Stanley Cup finals, and over the next four seasons only mustered a .500 record. As the Mets faltered so did the fan base, and by the end of the 1923–1924 season both the team and the Arena were having financial difficulties. The final year of the team's lease was bought out and the Arena was converted into a parking garage, a role it filled until 1961 when it was demolished to make way for an office building. The loss of the Arena effectively ended hockey in Seattle for the near future as there were no other artificial ice rinks in the area.

Frank Foyston and Jack Walker were the fan favorites on the Mets. Foyston, a rover in the seven-man game played in the PCHA, was a consistent scorer known throughout the league for his clean play. Walker, also a forward, was not as flashy as Foyston and was better known for his defensive abilities, particularly his use of the hook check, a maneuver he is often credited with inventing. Defensively, the team was led by Bobby Rowe, a pint-sized blueliner who packed a big punch; he was the most penalized player in franchise history. Goalie Harry "Happy" Holmes backstopped the team during eight of its nine seasons and was widely acknowledged as one of the top netminders in all of hockey.

The Metropolitans formed the foundation for the future of hockey in Seattle. Overall the franchise had a 112-96-2 record, including a remarkable 73-30-0 at home. The city hosted two Stanley Cup finals, and the team made it to the PCHA playoffs six times. Though the loss of the Arena forced hockey into a four-year hiatus, a following had been developed for the game over the course of the Mets' nine seasons. A number of former Mets would be key figures in the return of hockey to the city in 1928, and their popularity contributed greatly to the success of the teams that followed.

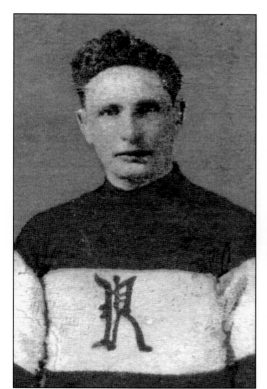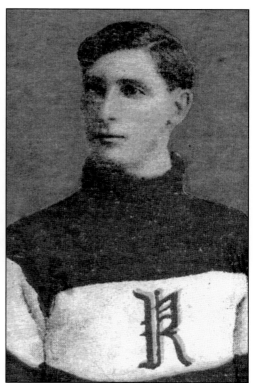

Frank (left) and Lester (right) Patrick first encountered hockey in the mid-1890s while growing up in Montreal. Lester was the older of the two, and his early hockey career included two Stanley Cups with the Montreal Wanderers in 1906 and 1907. Frank also had a distinguished career, playing with McGill University and professionally in Montreal and Renfrew. The brothers moved to Nelson, British Columbia in 1907 to work in the family lumber business, which was very successful. After selling the business in 1911, the family decided to move farther west to found and operate a professional hockey league based in Vancouver. The Pacific Coast Hockey Association's first game took place in Victoria on January 2, 1912, with the New Westminster Royals defeating the Victoria Senators by a score of 8-3. The league operated for 13 seasons between 1911 and 1924 before merging with the Western Canada Hockey League. The PCHA brought professional hockey to a number of cities in the Pacific Northwest including Vancouver, Victoria, New Westminster, Seattle, Spokane, and Portland. Lester coached and played defense in Seattle during the 1917–1918 season.

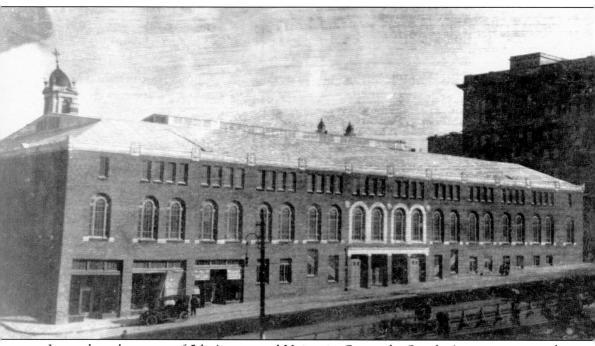

Located on the corner of 5th Avenue and University Street, the Seattle Arena was a marvel of modern technology. Measuring 240 feet long by 120 feet wide, the roof of the building was supported by 120-foot long trusses, meaning that there were no pillars inside to obstruct the view of spectators. The 75-ton refrigeration plant was state of the art, pumping freezing brine through eight miles of pipe laid in the floor to create an artificial ice surface, one of less than a dozen like it in the world. The structure consisted of over half a million bricks and 200 tons of steel, and the interior had 4,000 opera-style chairs and a heating system which ensured the occupants would remain warm even during winter hockey games. The ice surface was 200 feet long and 80 feet wide, fairly comparable to modern rink standards, and a floor could be placed over it to allow the building to host other indoor events. Constructed in just three months during the summer of 1915, the Arena served as the home to the Seattle Metropolitans from 1915 through 1924 before being converted into a parking garage, a role it filled until its demolition in the 1960s. (Courtesy of Dave Eskenazi.)

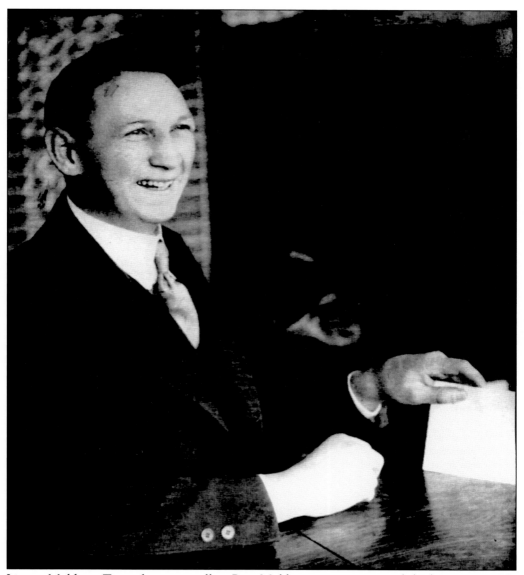

Linton Muldoon Tracy, known to all as Pete Muldoon, was an accomplished sportsman. He was a light heavyweight boxing champion, played professional lacrosse and hockey, and was an excellent figure skater. He later turned his attention to hockey coaching and, after a season with the Portland Rosebuds, moved to Seattle to manage the Metropolitans in 1915, a post he would hold for all but one of the team's nine seasons. Over that period he led the club to three Stanley Cup finals, winning the championship in 1917. During the 1919 Stanley Cup finals in Seattle against Montreal, he was one of a number of players and team personnel to be affected by the influenza epidemic that eventually led to the cancellation of the series and the death of Joe Hall of the Canadiens. After the Mets folded in 1924, Muldoon looked after his racetrack concessions business before moving to Chicago to become the head coach of the NHL's Black Hawks. His firing from that club in 1927 led to "Muldoon's Curse," a hex he placed on the team which prevented it from finishing in first place for 40 years until it was finally broken in 1967. (Courtesy of Dave Eskenazi.)

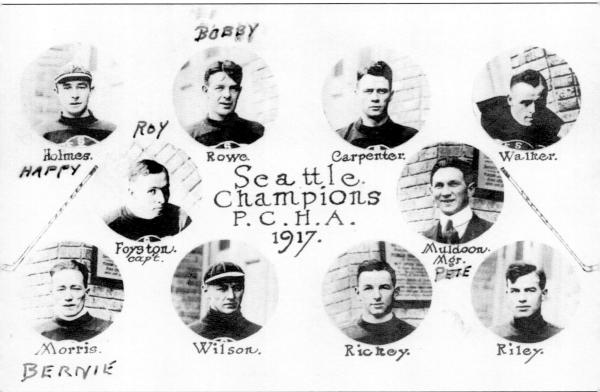

BOBBY

ROY

Holmes. Rowe. Carpenter. Walker.

HAPPY

Seattle.
Champions
P.C.H.A.
1917.

Foyston.
capt.

Muldoon.
Mgr.
PETE

Morris. Wilson. Rickey. Riley.

BERNIE

The Metropolitans entered their second PCHA season in 1916–1917 after finishing with a 9-9 record the previous year. The team was led offensively by Bernie Morris, the league's top scorer with 37 goals and 17 assists. The league championship wasn't decided until the final day of the season, with Seattle needing a win in Portland to clinch the title. If the Mets lost, they would have faced a possible tie and a playoff with Vancouver. An entire train car full of fans made the trip south to Portland, where a crowd of 4,000 packed the local arena. The teams took a 2-2 tie into the third period before the Mets pulled away on goals by Morris and Frank Foyston, winning the contest 4-3. The regular season title earned the Mets the right to host the defending champion Montreal Canadiens in a best-of-five series for the Stanley Cup. After losing the first game to the visitors, the Mets stormed back and won the next three straight to claim the Stanley Cup, the first American-based team to earn that honor. Seattle outscored Montreal 23-10 in the series, with the majority of the Mets' goals coming from the sticks of Morris (14) and Foyston (7). Due to the high travel expenses incurred by the Canadiens, the winner's share of the purse amounted to only $180 per player, compared to $120 per man for the losers. To help make up some of the costs, the clubs traveled south to California for a series of exhibition games, with Montreal winning two of three over Seattle. The 1917 Metropolitans are pictured here from left to right: (bottom row) Bernie Morris, Carol "Cully" Wilson, Roy Rickey, and Jim Riley; (middle row) Frank Foyston and Pete Muldoon; (top row) Harry "Happy" Holmes, Bobby Rowe, Ed Carpenter, and Jack Walker. Riley is the only man in history to play in both the NHL (Chicago and Detroit, 1926–1927) and major league baseball (1921 St. Louis, 1923 Washington). (Courtesy of Dave Eskenazi.)

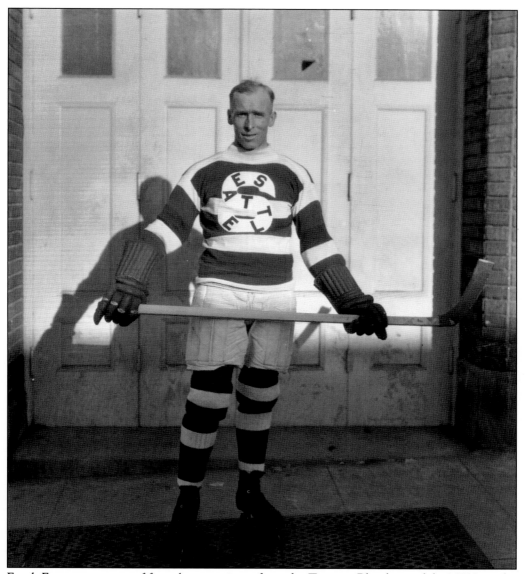

Frank Foyston was one of five players to jump from the Toronto Blueshirts of the NHA to the newly formed Seattle Metropolitans prior to the 1915–1916 season. Primarily a rover, he was a member of the Mets for all nine seasons from 1915 through 1924, missing only eight regular season games during that span. He was the team's all-time leader in games played (202), goals (174), points (227) and playoff game appearances (26). Foyston played on all three of Seattle's Stanley Cup squads, and won the coveted cup with three different teams: 1913–1914 Toronto Blueshirts, 1916–1917 Seattle Metropolitans, and 1924–1925 Victoria Cougars. After a four-year stint in Detroit in the late 1920s, he returned to Seattle and coached the Seahawks for four seasons, leading them to a NWHL championship in 1936. He was inducted into the Hockey Hall of Fame in 1958. (Courtesy of the Pemco Webster & Stevens Collection, Museum of History & Industry.)

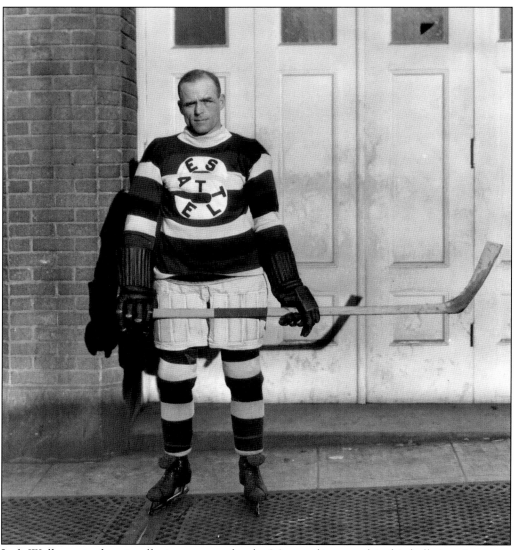

Jack Walker suited up in all nine seasons for the Metropolitans and is third all-time in games played (185) and points (140) for the franchise. He played all of the forward positions, but is best known for his defensive play, often being credited with inventing the hook check and popularizing its use. Walker played two seasons professionally in Toronto, winning the Stanley Cup in 1914, before jumping contract with a number of his teammates to come out west to play in the PCHA. After the demise of the Mets, Walker played two seasons with the Victoria Cougars (winning a Stanley Cup in 1925) before making the move to the NHL with the Detroit Cougars from 1926 through 1928. When hockey returned to Seattle in the fall of 1928, Walker too returned to the city. He retired from play following the 1931–1932 season at the age of 46 and was posthumously elected to the Hockey Hall of Fame in 1960. (Courtesy of the Pemco Webster & Stevens Collection, Museum of History & Industry.)

Fred "Mickey" Ion followed up a brief stint as a professional lacrosse player by becoming a hockey referee in the PCHA in 1912. He officiated most of the Seattle Metropolitan games during the league's 13 seasons before moving on to a long career in the NHL (1926–1943). Ion was involved in a number of celebrated incidents in the rough-and-tumble game of the early part of the century, including punching out a heckler seated in the front row during a playoff game between Seattle and Vancouver in 1924. In an ironic and tragic twist of fate, the man who made his living on skates would later lose both legs to amputation after contracting phlebitis, though he survived long enough to witness his induction into the Hockey Hall of Fame in 1961. (Courtesy of the *Seattle Post–Intelligencer* Collection, Museum of History & Industry.)

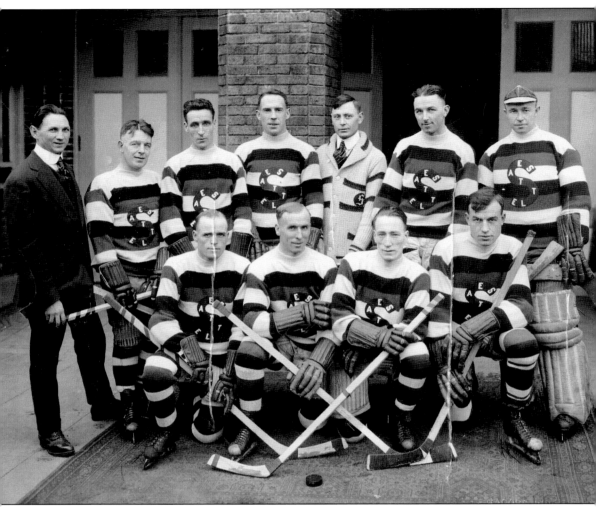

Over the course of nine PCHA seasons (1915–1924) the Seattle Metropolitans compiled a 112-96-2 record, including an impressive 73-30-0 at home. They had a winning record against every team in the PCHA and won the league title three times, earning the right to play for the Stanley Cup in 1917, 1919, and 1920. The Mets had a 7-6-1 record in Stanley Cup games, winning one series, losing one, and playing to a draw in 1919. Four members of the Mets have been inducted into the Hockey Hall of Fame: Frank Foyston, Harry Holmes, Lester Patrick and Jack Walker. This photo dates from the early 1920s and includes, from left to right, (front row) Jack Walker, Frank Foyston, Bernie Morris, and Jim Riley; (back row) Pete Muldoon, Bobby Rowe, unknown, unknown, unknown, Roy Rickey, and Harry Holmes. (Courtesy of Dave Eskenazi.)

Bernie Morris spent eight seasons with the Metropolitans between 1915 and 1923, leading the team in scoring five times. His 23 goals in 1915–1916 led the PCHA, and he led the league in total scoring with 54 points the following season. Morris was the star of the 1917 Stanley Cup series against Montreal, scoring six goals in the final game and 14 in the four-game series. He missed the 1919 Stanley Cup finals when he was arrested for draft evasion just prior to the end of the season. He was held in custody for almost a year before being acquitted, forcing him to miss the entire 1919–1920 regular season, though he was released in time to play in the 1920 Stanley Cup finals against Ottawa. Morris was involved in another bizarre incident in December of 1922 when he accidentally ingested poison, which he thought was cold medication. The poison left him unconscious and it took him about two weeks to fully recover. Traded to the Calgary Tigers in October of 1923, Morris played another seven seasons before retiring in 1930.

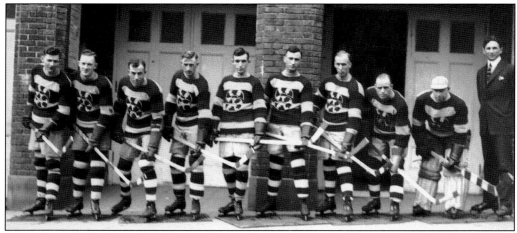

While the Metropolitans were a solid club during the regular season, finishing with a losing record only once, the playoffs were a different story. Created during the 1917–1918 season, the PCHA playoffs matched the league's two top teams in a two-game, total goals format—the team scoring the most goals over the course of two games won the league championship. Each team played one home game. The Mets made it to the playoffs six times, but only managed a 2-8-2 record in those games. All six series were played against the Vancouver Millionaires, and the Mets only won the league title twice (1919 and 1920).

Defenseman Gord Fraser played three seasons for the Seattle Metropolitans between 1921 and 1924. Shown here in a rare photo of the interior of the Seattle Arena, Fraser scored 14 goals in 30 games during the 1923–1924 season, the third best total on the club. He won a Stanley Cup with the Victoria Cougars in 1925 before moving on to the NHL, where he played five seasons from 1926 to 1931. (Courtesy of the *Seattle Post–Intelligencer* Collection, Museum of History & Industry)

TWO

The Early Professionals (1928–1941)

The construction of the Civic Arena in 1927, part of a three-building complex which included the Civic Auditorium and Civic Stadium, allowed hockey to return to Seattle. Located on the corner of 4th Avenue North and Mercer Street, it held over 5,000 spectators for hockey and would be the home of Seattle-based teams for much of the next 67 years.

Pete Muldoon, former manager of the Metropolitans, was determined to bring hockey back to Seattle. With the Civic Arena nearing completion, he put together a group of investors to form the Seattle Ice Skating and Hockey Association. A new four-team league was created, known as the Pacific Coast Hockey League (PCHL), and the Seattle entry was dubbed the Eskimos. In an effort to attract fans of the old Metropolitans, Muldoon's team kept the same striped jerseys (with a slightly different logo) and brought back Jack Walker, the popular forward from the Stanley Cup champs. Though Walker was now forty years old and past his prime, he was still a fan favorite and a solid two-way player. Attendance was good during the inaugural season, and Muldoon began to scout locations in nearby Tacoma with the thought of building a rink and establishing a team there. It was during one of these trips on March 13, 1929, that Muldoon suffered a heart attack and died at the age of 47.

Without their leader the Eskimos faltered, both on the ice and at the gate, and after three seasons the team was gone. Seattle was without professional hockey from the spring of 1931 to the fall of 1933, and local fans had to satisfy themselves with the play of the amateur City Hockey League. In 1933 a new pro league was formed, the Northwest Hockey League (NWHL). Hugh Caldwell, who took over the Seattle Ice Skating and Hockey Association after Muldoon's death, was the owner of the Seattle franchise, known as the Seahawks (sometimes referred to as "Sea Hawks"). In keeping with the tradition of having former Metropolitans involved in the organization, Frank Foyston was named manager of the club and Jack Walker, who had recently retired as a player, was the league's referee in Seattle. The key to the team's success was the signing of 23-year-old forward Hal Tabor, who went on to play eight seasons with the franchise and was always one of the top scorers on the team.

After a disappointing fourth place finish in 1933–1934, the Seahawks overhauled the roster for the next campaign. The new team was much improved, and after losing the opening game of the 1934–1935 season the club went on a 13-game unbeaten streak, finishing the season in first place with a 20-9-3 record. They faced the Vancouver Lions in the best-of-five NWHL finals, losing the fifth and deciding game at home in overtime by a score of 2-1. Foyston was fired after the playoff failure and replaced by Art Gagne, but the team had no success under the new manager and opened the 1935–1936 season with only three wins in their first 10 games. Gagne was quickly released and Foyston brought back into the fold. The team responded immediately and led by the "Goal Dust Twins," Hal Tabor and Sammy McAdam, climbed out of the cellar to the top of the standings, finishing the season in first with a 19-14-6 record. They once again faced the Lions in the league finals, this time winning the series three games to one for their first NWHL title. It was Seattle's first hockey championship since 1920, and the victory ended a streak of six consecutive playoff series losses to Vancouver clubs dating back to 1921. The Seahawks made two more trips to the league finals in 1938 and 1939, but were unable to win another championship. In 1939–1940 the club finished last in a consolidated three-team NWHL, even though they had four of the top five scorers in the league.

Prior to the start of the 1940–1941 season the club was sold by attorney Phil Lycette, who had taken over the Seahawks in February of 1936, and the new ownership group changed the name of the team to the Olympics. The league had been suffering financially for a number of years, and things were no different in Seattle. The new owners were fans of the game and really wanted it to succeed in their hometown, but with an average team and World War II already underway in Europe and Asia there simply wasn't enough interest. The NWHL folded after the 1941 playoffs and Seattle was again without professional hockey, this time until 1948.

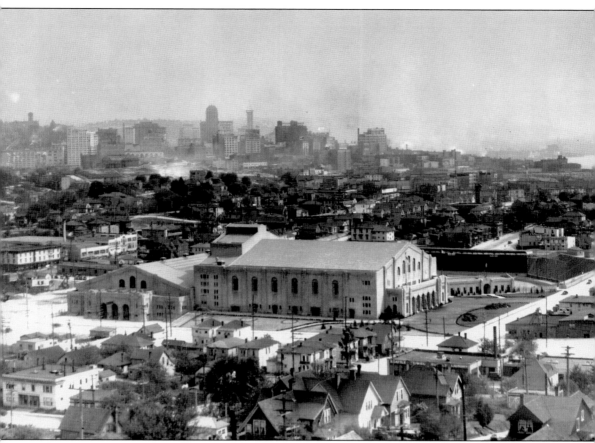

The Civic Arena was constructed as part of the three-building Civic Complex completed in 1927. In this photo the Arena can be seen on the left side, with the larger Civic Auditorium in the center and Civic Stadium to the right. The complex was built on land donated to the city of Seattle by David and Louise Denny in 1889, and was financed through a $900,000 city bond as well as funds bequeathed by late saloon owner James Osborne. The Arena, located on the corner of 4th Avenue North and Mercer Street, has been known by many names over the years: Civic Arena, Civic Ice Arena, Mercer Street Arena and Mercer Arena to name a few. The seating arrangement inside is horseshoe shaped, with no seats on the south side of the building. The capacity for hockey has changed over time, varying between 4,000 and 6,000 depending on the style and size of the seats. The construction of the Arena, with its artificial ice plant, allowed hockey to return to Seattle after a four-year hiatus. It opened with an ice skating exhibition on November 7, 1928, and the first hockey game was played a few weeks later on November 24. A crowd 6,000 fans turned out for the game between the Seattle Eskimos and the Portland Buckaroos, won 5-2 by the Eskimos. Cecil Browne scored the first goal in the new building on a pass from former Metropolitan Jack Walker early in the first period. The Arena continued to serve Seattle hockey for 67 years, hosting its last game on October 28, 1995 as the Seattle Thunderbirds defeated the Saskatoon Blades by a score of 7-4. Subsequent remodels have left the Arena without an ice plant and it is no longer suitable for hockey. (Courtesy of the Pemco Webster & Stevens Collection, Museum of History & Industry.)

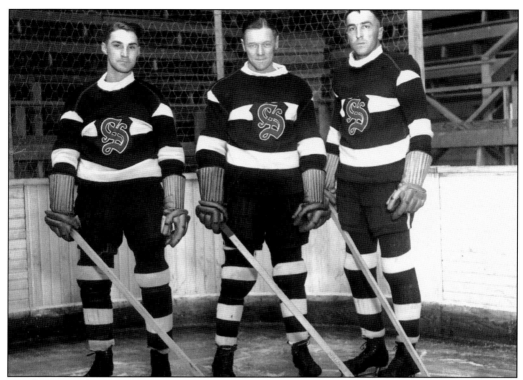

Cecil Browne (center) was the top scorer on the Eskimos during his two seasons in Seattle from 1928 to 1930. His 23 goals in 1928–1929 were more than double the number scored by the next closest player, and his 22 points in 1929–1930 led the entire PCHL. Big Earl Overand (right) played both defense and forward during the 1928–1929 season for the Eskimos, though his usefulness was hampered by an early season ankle injury which caused him to miss a number of games. (Courtesy of the *Seattle Post–Intelligencer* Collection, Museum of History & Industry.)

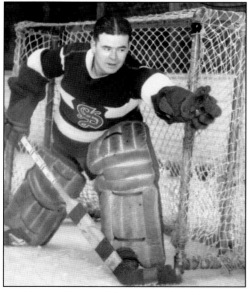

Hal Yorke's mustache was one of the more interesting stories of the 1928–1929 season. The new Seattle netminder wore a mustache, which was fairly unusual in that era among athletes and caused quite a sensation in the press. When he led the Eskimos to four wins in their first five games, Yorke became the toast of the town. He guaranteed a win against second place Vancouver on December 7, stating that if the Eskimos lost he would shave his mustache. They lost the game 1-0, and Yorke followed through on his promise. Unfortunately, much like Sampson lost his strength after his hair was cut, the clean-shaven Yorke lost his power, and the Eskimos went on an eight game winless streak (0-7-1) that eventually cost the goaltender his job. He finished the season with a 4-8-1 record. (Courtesy of the *Seattle Post–Intelligencer* Collection, Museum of History & Industry.)

Samuel "Porky" Levine was signed by the Eskimos in January of 1929 to replace struggling goaltender Hal Yorke. Manager Pete Muldoon used his connections to acquire Levine from the Detroit Olympics, then managed by former Metropolitan Frank Foyston. The new goalie was an instant sensation, putting together back-to-back shutouts in his first two games in Seattle. He went 12-7-0 on the season, earning four shutouts along the way. His style was unlike that of any other netminder, as he frequently left his feet to block the goal mouth with his body, a tactic that was considered to be unfair by many. Portland fans were so incensed at Levine's style that following a 3-0 shutout on January 24 there was a riot in the building as the Portland fans, who had pelted him with debris throughout the game, tried to get at the goalie. League referee Mickey Ion warned Porky that his technique, while not illegal, would not be tolerated and that penalties would be called against him if he continued. Levine's Jewish heritage was a hot topic in the local press, and his religion was mentioned in almost every account written about him. (Courtesy of the *Seattle Post–Intelligencer* Collection, Museum of History & Industry.)

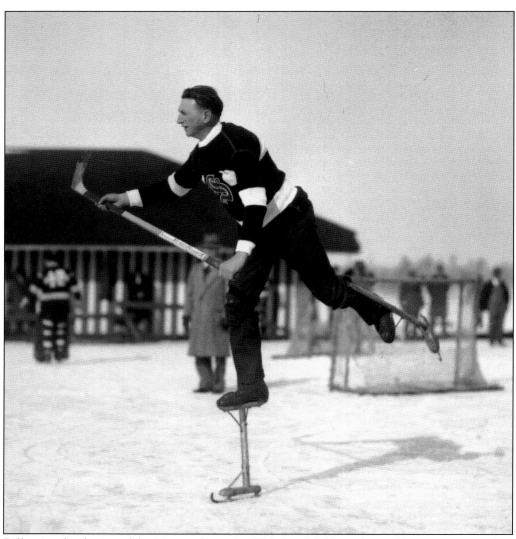

Following the demise of the Metropolitans in 1924, Pete Muldoon focused his energies on other business ventures. With the construction of the Civic Arena in 1927 he saw an opportunity to bring hockey back to Seattle and immediately went to work, putting together a group of investors to form the Seattle Ice Skating and Hockey Association. Muldoon's group helped create the PCHL and establish the franchise in Seattle. Unfortunately Muldoon would not see the end of the league's first season. He passed away of a heart attack on March 13, 1929 while scouting locations in nearby Tacoma, looking for land upon which to build a hockey arena. Muldoon is shown here skating on stilts, a trick for which he was well known. The photo was taken on March 6, 1929, just one week before his untimely passing. The Pete Muldoon Trophy was created in his memory and for a time was awarded to the Seattle player deemed the most inspirational by his teammates. (Courtesy of the *Seattle Post–Intelligencer* Collection, Museum of History & Industry.)

Nate Druxman (right), shown here with heavyweight boxing champion James Braddock (left), was one of the original investors in the Seattle Ice Skating and Hockey Association. A local entrepreneur and boxing promoter, Druxman was a long-time fixture in the Seattle sports scene. Following the death of his friend Muldoon in the spring of 1929, Druxman briefly took control of the association before selling his shares to Hugh Caldwell, one of the original investors, later that same year. Majority interest of the association was sold to Caldwell's law firm partner Phil Lycette in February of 1936, making him the majority owner (80 percent) of the then Seahawks for the next four years. After Druxman left the hockey scene he turned his attention back to boxing matches, which he continued to promote until 1942. (Courtesy of the *Seattle Post–Intelligencer* Collection, Museum of History & Industry.)

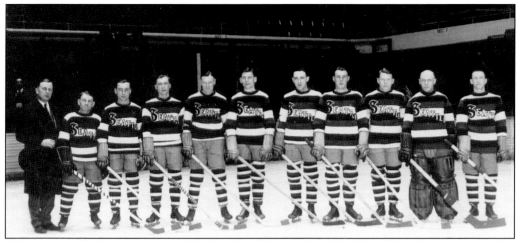

The 1929–1930 Seattle Eskimos, shown here from left to right, are Lloyd Turner (manager), Bobby Benson, Max Sutherland, Ollie Reinikka, Cecil Browne, Tony Savage, Henry "Smokey" Harris, Art Townsend, Dan Daly, Hal Winkler and Ernie Anderson. The team finished third in the four team PCHL with a 15-13-8 record, failing to earn a spot in the playoffs.

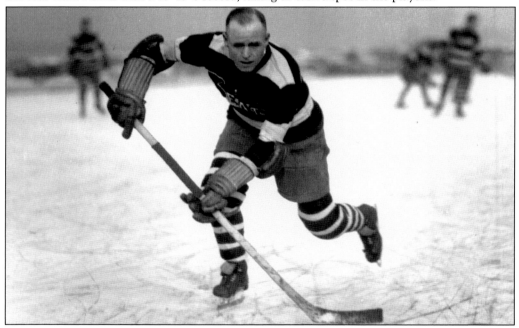

Jack Walker was a fan favorite during his nine seasons with the Metropolitans, and when hockey returned to Seattle after a four-year layoff the new owners wisely brought him back to generate some excitement. While the 40-year-old Walker had lost a step, he was still a strong contributor to the Eskimos, playing in all three seasons between 1928 and 1931 and leading the league in assists twice. He also scored the first goal in team history during a 4-2 win in Portland on November 22, 1928. Walker remained part of the hockey scene in Seattle after his retirement as a player, serving as both a referee and a linesman in various professional and amateur leagues. (Courtesy of the *Seattle Post–Intelligencer* Collection, Museum of History & Industry.)

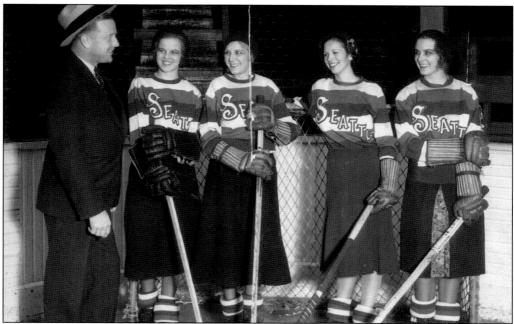

This pair of promotional photos from circa 1930 combines women and hockey. While it is unclear exactly how these images were used, they likely served a dual role in advertising the game to both men and women. Male sports fans of the era would certainly have been interested in photos that combined sports and attractive women. Conversely, they may also have been intended to create more interest in the game on the part of female fans by showing women in association with the game. The top photo shows four women in Eskimos sweaters with an unidentified man. The bottom photo shows two women skating with Eskimos forward and long-time Seattle player Jack Walker. (Courtesy of Dave Eskenazi.)

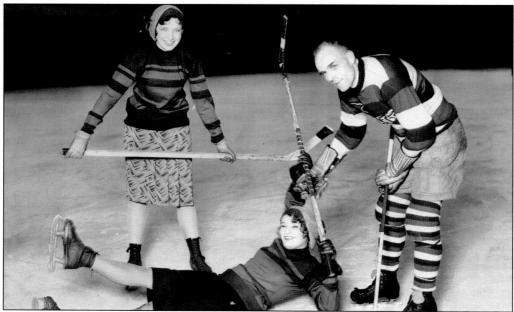

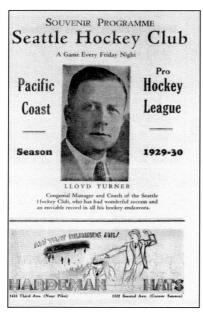

Lloyd Turner was the coach and manager of the Eskimos from 1929 to 1931. He came to Seattle from the Minneapolis Millers, a team he coached to the US Amateur Hockey Association championship in 1928. He brought a number of his former players out west, and the team had two good seasons under him including a first place finish in 1930–1931. While the Eskimos were a combined 31-22-17 under Turner, they didn't have much success in the postseason, missing the playoffs in 1929–1930 and losing in the league finals to Vancouver in 1930–1931.

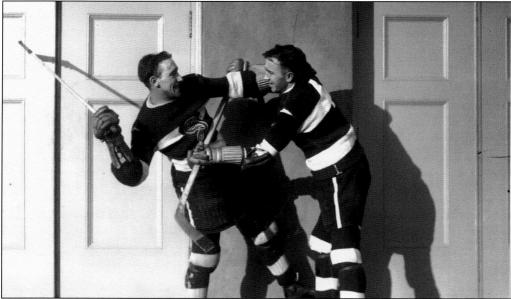

Hockey was a rough game in the 1920s and 1930s. While this photo was obviously intended to be comical, violence on the ice and in the stands was not uncommon. The 1930–1931 season was particularly brutal as Eskimos newcomer Bobby Connors ran roughshod over the entire league. Connors had a number of fights and run-ins with other players, fans and officials, culminating in a stick fight with Bill Brennan of Vancouver on March 6, 1931. Brennan received a bad cut on his head and a concussion, forcing him out of the lineup for the remainder of the season. The incident started a riot when Connors was ejected from the game and fined $25, and the police and fire department had to forcibly clear the fans from the lobby of the Civic Arena to prevent any further trouble. (Courtesy of the *Seattle Post–Intelligencer* Collection, Museum of History & Industry.)

Jack Riley made his professional debut with the Eskimos on January 17, 1930. He played sporadically with the team that season, making it into five games and being kept off the score sheet. The 19 year old was praised in the press for his great effort and there were hopes that he would be a regular with the club the following season, but Riley opted to go back to the amateur ranks. (Courtesy of the *Seattle Post–Intelligencer* Collection, Museum of History & Industry.)

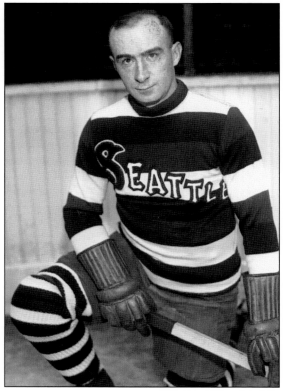

Bill "Red" Stuart had a successful seven-year NHL career from 1920 to 1927, winning the Stanley Cup with Toronto in 1922. After his time in the NHL, Stuart returned to amateur hockey and played three seasons with the Minneapolis Millers, two of which were under Lloyd Turner. Stuart joined Turner in Seattle for the 1930–1931 season and was named captain of the Eskimos. (Courtesy of the *Seattle Post–Intelligencer* Collection, Museum of History & Industry.)

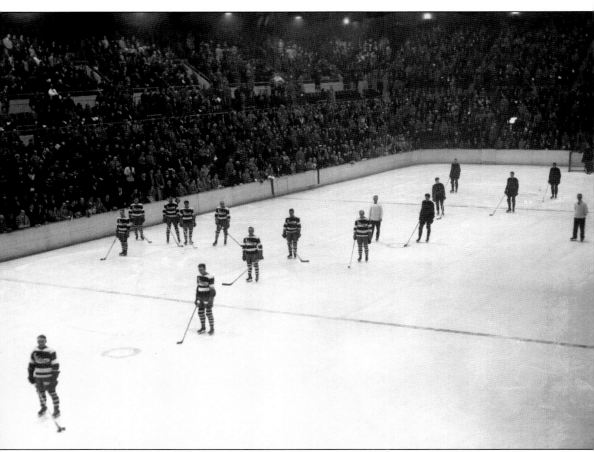

The Eskimos played their home games in the Civic Arena, the home to all of Seattle's professional and amateur hockey teams from 1928 to 1964. During the 1930s the Arena had a seating capacity of roughly 5,500 fans for hockey, though subsequent remodels lowered this number. As can be seen in this photo circa 1930, only the rink boards separated the players from the fans in the front row. It would be another 25 years before a fence was finally erected on the boards, serving the dual purpose of protecting the fans from flying pucks and sticks, while also protecting the players from irate fans who were known to grab sticks or take a swing at opposing skaters.

Rookie Tony Hemmerling (left) is shown getting advice from coach Frank Foyston (right) during the 1933–1934 season. Hemmerling played two full seasons with the Seahawks before heading east to continue his professional career. Foyston coached the Seahawks from 1933 to 1935, but was let go following a disappointing loss to Vancouver in the 1935 finals. He was replaced prior to the start of the 1935–1936 season by playing coach Art Gagne, who lasted only 10 games (with a 3-7-0 record) before he too was fired and Foyston brought back. The team went 17-7-6 after the return of Foyston, eventually defeating Vancouver in the finals for Seattle's first league championship since 1920. (Courtesy of Sharon Hemmerling Silzel.)

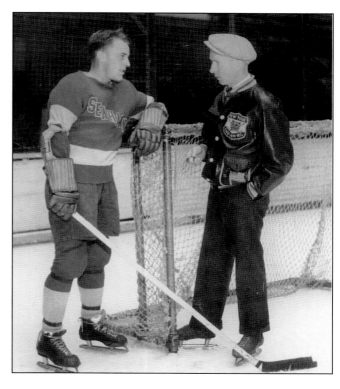

Tony Hemmerling joined the Seattle Seahawks as a 19-year-old rookie during the 1933–1934 season. He made an immediate impression on the home-town fans, engaging in a massive opening night brawl with Ade Johnson of Edmonton that continued in the penalty box before both players were ejected. In addition to being tough, Hemmerling was also a skilled forward and was third in the league in scoring in 1934–1935 with 21 goals and 33 points. Tony was a holdout at the start of the 1935–1936 season, disappointed that Seattle didn't sell him to the NY Americans of the NHL over the summer. He was eventually released by Seattle and made it to the NHL later that season. (Courtesy of Sharon Hemmerling Silzel.)

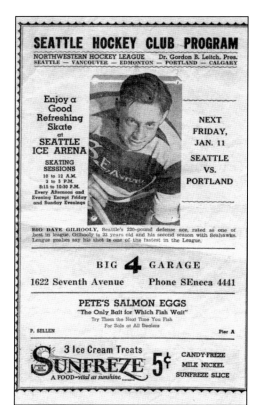

The 1934–1935 Seahawks finished in first on the strength of a 20-9-3 record. A 13-game unbeaten streak (11-0-2) early in the season put them ahead for good, and the roster included the second and third highest scorers in the league in Hal Tabor and Tony Hemmerling. They faced Vancouver in the best-of-five league finals, losing the fifth and deciding game at home in overtime by a score of 2-1. The disappointment surrounding the finals loss led to the firing of coach Frank Foyston following the series. (Courtesy of Dave Eskenazi.)

The 1934–1935 Seattle Seahawks, pictured from left to right, are (seated) Frank Foyston (coach), Hal Tabor, John Houbregs, Sammy McAdam, Les Whittles, Tony Hemmerling, Johnny Sheppard, and Emmett Venne; (standing) Riley "Moon" Mullen, Dave Gilhooly, Cameron Proudlock. (Courtesy of Sharon Hemmerling Silzel.)

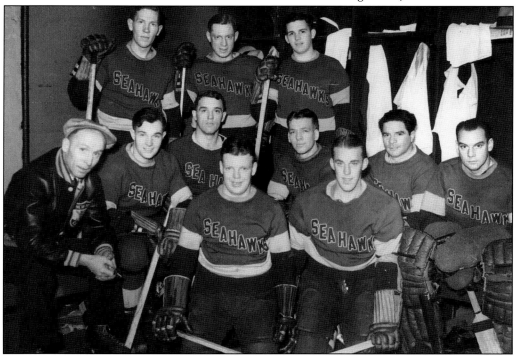

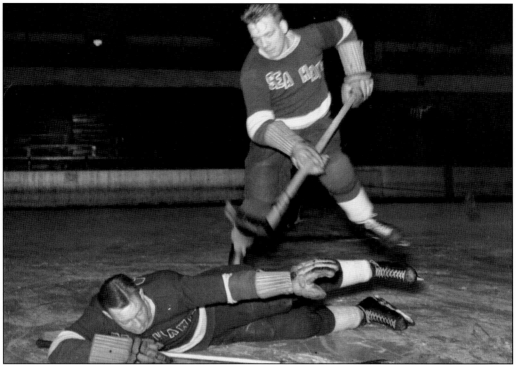

Les Whittles (standing) played three seasons with the Seahawks from 1933 to 1935 and 1936–1937. He was a competent winger, averaging 11 goals per season with Seattle. Defenseman Dave Gilhooly (prone) was one of the most feared players in hockey. He spent four seasons with the Seahawks (1933–1937) and another with the Olympics (1940–1941), and was consistently one of the most penalized players on his team. During World War II he played two seasons in the City Hockey League with Boeing and the Boilermakers. (Courtesy of the *Seattle Post–Intelligencer* Collection, Museum of History & Industry.)

When left wing Frank Daley joined the Seahawks midway through the 1936–1937 season, he was already an eight-year veteran. During his four seasons in Seattle from 1936 to 1941, his goal production increased every year, and by 1940–1941 he was the leading scorer on the Olympics with 28 goals and 59 points. He also played two seasons in Seattle during World War II, appearing with the Isaacson Ironmen in 1943–1944 and with Sick's Stars in 1944–1945. (Courtesy of the *Seattle Post–Intelligencer* Collection, Museum of History & Industry.)

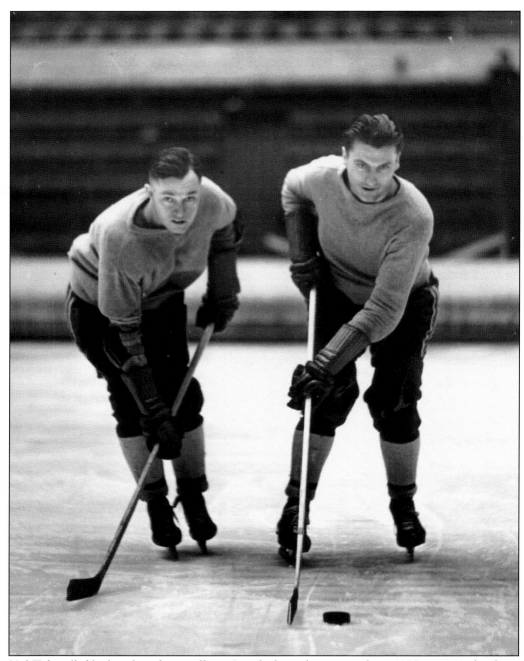

Hal Tabor (left) played professionally in Seattle for eight seasons from 1933 to 1941, finishing in first or second on the team in scoring seven times. He was the most prolific scorer of the era (1928–1941) in Seattle, picking up 179 goals and 319 points. Sammy McAdam (right) skated four seasons with the Seahawks from 1934 to 1938, leading the team in scoring twice. During their time together the pair were dubbed the "Goal Dust Twins" for their remarkable combination work and goal-scoring prowess. (Courtesy of the *Seattle Post–Intelligencer* Collection, Museum of History & Industry.)

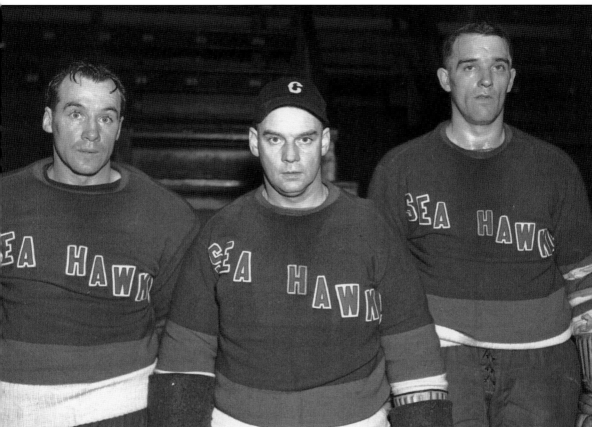

Frank Daley (left) played four seasons in Seattle with the Seahawks and Olympics from 1936 to 1941, leading the team in scoring during his final season with 28 goals and 59 points. Goaltender Emmett Venne (center) played in six seasons with the Seahawks between 1933 and 1939, helping the club to three first place finishes and one league championship. Venne was extremely durable, missing only one start during those six seasons and winning 106 games, the most ever by a Seattle goalie. John Houbregs (right) was a huge defenseman at 6-foot-2 and 215 pounds, making him one of the largest players of that period. Houbregs had a long career in Seattle, playing with the Eskimos in 1930–1931 and the Seahawks from 1934 to 1936 and again from 1937 to 1939. He also played a number of seasons in the City Hockey League during the 1930s and '40s. John is perhaps most famous in Seattle for being the father of University of Washington basketball standout Bob Houbregs, who later went on to play in the NBA and was inducted into the Basketball Hall of Fame. (Courtesy of the *Seattle Post–Intelligencer* Collection, Museum of History & Industry.)

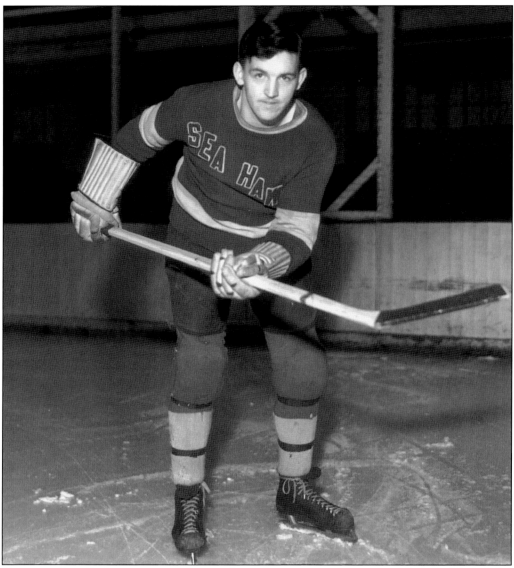

Cameron Proudlock was one of the roughest players ever to suit up in Seattle. He led the Seahawks in penalty minutes twice during his three seasons with the team from 1934 to 1937, but was also a solid forward who averaged 11 goals per season. His toughness was legendary—he suffered a broken cheekbone on February 26, 1936, but returned to action less than a month later to skate in the playoffs, helping the Seahawks to their only championship. Proudlock became a PCHL referee in the late 1930s but still couldn't stay away from a fight, knocking out Portland coach Bobby Rowe in an argument during a 1941 contest. He returned to Seattle to play in the City Hockey League during World War II. On January 4, 1942, his four goals and four assists in a single game tied a league record. During the 1942–1943 season he became more known for his erratic temper than his scoring touch, receiving two misconducts in the first eight games of the season at the hands of referee Bill Knott and later punching the official during a game. (Courtesy of the *Seattle Post–Intelligencer* Collection, Museum of History & Industry.)

Ron Moffatt played three seasons with the Seahawks from 1937 to 1940. After retiring he opened a bar in Seattle known as the Hub Tavern, located at 421 Denny Way. As can be seen from this matchbook cover, Moffatt used his popularity as a hockey player to advertise for his establishment. The reverse reads: "Where hockey players… and friends meet." A number of other former players went on to operate successful businesses in the Seattle area following their playing careers.

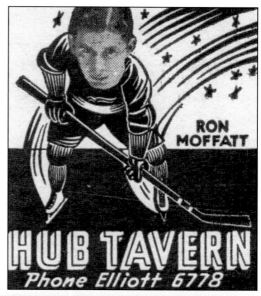

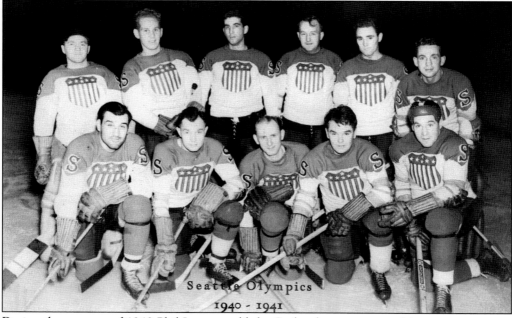

Seattle Olympics
1940 - 1941

During the summer of 1940 Phil Lycette sold the Seahawks to an ownership group consisting of Jerry O'Neil (florist), Pete Pergolios (coal mine owner) and Folger Peabody (oil company executive). Peabody was well known in the local sports scene and was often referred to as "Seattle's number one fan" in the press, being heavily involved in baseball and hockey. The new owners renamed the club the Olympics and brought in former Seahawk Danny Cox as coach. The team struggled both at the gate and on the ice as injuries mounted and its record floated around .500. The Olympics finished the season at 20-21-7 before being swept in the first round of the playoffs by Vancouver. The PCHL folded following the 1941 playoffs due to league-wide financial difficulties, leaving Seattle with only the amateur City Hockey League. (Courtesy of Dave Eskenazi.)

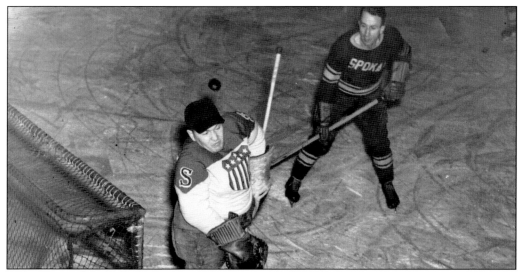

Olympics goaltender Paul Gauthier takes a shot up high during a February 6, 1941, game in Spokane. It was a tough year for the little (5'5" tall) goalie from Winnipeg. He arrived in Seattle late, missing the first two games of the season. In his first game with the Olympics he was knocked unconscious by a stick to the head, forcing him to miss the following game. The night after this photo was taken Gauthier suffered his second serious injury of the season when he was struck in the eye with a puck, forcing him to miss another four games. Because teams did not carry a second goaltender on their roster, the Olympics were forced to use players from the City Hockey League or other amateur circuits to fill in when injuries like this occurred. If the goaltender was injured during the course of the game and could not continue, one of the other players had to don the pads and take his chances between the pipes. That happened twice for the Olympics during the season, with Vic Lofvendahl and Dave Downie both spending portions of a game in goal.

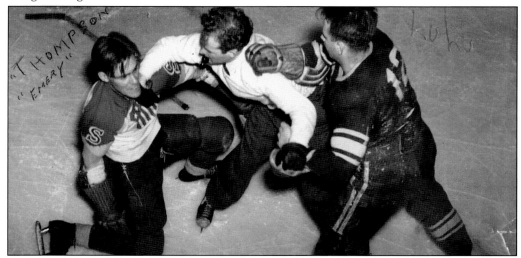

Jack Tomson (left) of the Olympics and Don Emery (right) of Spokane have a disagreement while referee Pat Murphy (center) tries to separate them. Tomson played one season in Seattle (1940–1941), scoring 14 goals and 32 points while also picking up 52 penalty minutes, the third highest total on the team.

Three

The Amateurs (1928–1948)

The completion of the Civic Arena in 1928 brought hockey back to Seattle, and for the first time a rink was available for amateurs to use. The City Hockey League (also known as the City League and the Seattle Ice Hockey League) quickly organized and began play. From 1929 to 1941 the league consisted of four teams from various parts of the city, often sponsored by local businesses. Doubleheaders were played on Sunday evenings with all four teams seeing action, and the schedule was around fourteen weeks long. A number of players and officials from the City League eventually went on to more prominent roles in local hockey: Bill Knott became a referee in the PCHL, WHL and the NHL; Vince Abbey became a local attorney and later one of the owners of the Totems in the 1960s and 1970s; Al Leader was the president of the PCHL and the WHL, and was elected to the Hockey Hall of Fame in 1969 in the "Builders" category.

The golden era of the City League took place between 1941 and 1944. With the US and Canada both embroiled in World War II and the military draft underway, many professional minor leagues ceased operations due to the lack of players and travel restrictions. Seattle was home to airplane factories and shipyards, and these war industry jobs attracted a number of former pros to the area, many of whom joined the league to play hockey on the weekends. At the start of the 1941–1942 season the league consisted of four teams, and though a pair of Portland squads joined play during the first few weeks neither was able to finish out the year. Five former Seattle pros suited up during the season, with the championship going to the Shurfine Grocers who defeated the Boeing Clippers in a best-of-three playoff series. The following season the league shrank to three teams, but now a dozen former professionals suited up to play. Young players came and went quickly as the draft called them to the armed forces (over 30 players from the City League were called to duty), making the older veterans the backbone of the circuit. In addition to the fourteen-game league schedule, a number of exhibitions were played by the league all-stars against military teams from Canada which raised money to buy sports equipment for servicemen overseas. The successes of the previous two seasons showed that hockey could continue during the war, and the league expanded to become the Northwest Industrial Hockey

League (NIHL) for the 1943–1944 season, with two teams in Seattle, two in Portland, and one in Vancouver.

One of the most pivotal events in Seattle hockey history took place during the summer of 1944 when the new Pacific Coast Hockey League (PCHL) was founded. While the PCHL was technically an amateur league, players were still paid for their services, though considerably less than the pros. The amateurs were under contract for only one season at a time, and their contracts did not have a reserve clause tying them to one team. This lack of control by team owners resulted in a lot of personnel moves every season, making it difficult to ice good teams on a consistent basis.

Seattle had two teams in the Northern Division of the new league during the 1944–1945 season. The Ironmen were sponsored by Isaacson Iron Works, and Sick's Stars were bankrolled by Emil Sick, a local brewer. The Stars looked to be the early favorites with former pros Dave Downie, Hal Tabor and Frank Daley on their roster, but the Ironmen proved to be the class of the league under new player/coach Frank Dotten. The season opened on October 8, 1944, with a match-up of the two local entries, and over 4,700 fans packed the Arena to the rafters to watch the Ironmen come away with a 5-3 win. The Ironmen led the division for most of the season and defeated Portland in the playoffs. A series with the Southern Division champions never materialized, but the Ironmen were given the opportunity to play the Boston Olympics of the Eastern Amateur Hockey League for the US Amateur Hockey Association championship. The heavily favored Olympics traveled west for a best-of-seven series to be played in both Seattle and Vancouver, winning the first two games in Seattle. The Ironmen rallied and won the next four straight to take the title, and Seattle had its first championship since 1936.

The following three seasons included interlocking schedules between the two divisions, with each team making one extended road trip. The Stars dropped out after only one year, leaving the Ironmen as the sole Seattle entry in the league. Dotten purchased the club in 1946, operating it for the next eight years. The league transitioned from amateur to professional in the fall of 1948, and later was renamed the Western Hockey League. During the 30 seasons in which the league operated between 1944 and 1974, Seattle was the most stable city in the circuit, icing a team in every season but one and playing more games than any other franchise in league history.

The City Hockey League was formed in the winter of 1929 following the construction of the Civic Arena, continuing into the 1940s. Usually it was a four-team circuit with teams representing different parts of Seattle. In later years clubs were named after their corporate sponsors including Ben Paris, Hullins, Shurfine Grocers, and the Day and Night Fuel Company. The program shown here is for a doubleheader played on December 2, 1934, featuring Queen Anne vs. Green Lake and Ballard vs. West Seattle. Playing center for West Seattle that evening was Al Leader, who later became the president of both the PCHL and WHL as well as a member of the Hockey Hall of Fame.

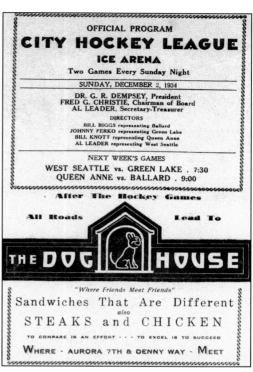

The City Hockey League drew well at the Civic Arena, averaging well over 2,000 fans per night. While the players were technically amateurs, they were paid and sometimes skaters were imported from other cities. This program from the 1939–1940 season features a match-up between Fisher's Blend and the Day and Night Fuel Company, with Vince Abbey playing forward for Day and Night. He later became a local attorney and was one of the owners of the Seattle Totems from 1958 to 1975.

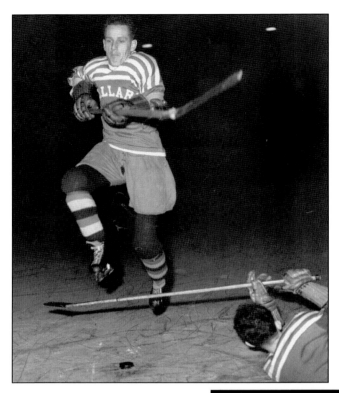

Ron McNulty (shown here with Ballard in 1940–1941) played a number of years in the City Hockey League. During the 1941–1942 season he appeared with the Ben Paris Orphans, playing left wing. Ben Paris, a local sportsman and entrepreneur, operated an establishment bearing his name on Fourth Avenue. It had everything a man could want—food, alcohol, billiards, pull tabs, sporting goods, a barbershop and a huge aquarium full of live bass. Despite the great sponsor, the Orphans finished in the cellar with a 7-12-0 record and didn't complete the season. (Courtesy of the *Seattle Post–Intelligencer* Collection, Museum of History & Industry.)

Ron Moffatt (left) and Ron "Peaches" Lyons (right) were NHL veterans and both had played professionally with the Seahawks—Moffatt from 1937 to 1940 and Lyons from 1935 to 1937. They joined forces on the Ben Paris Orphans for the 1941–1942 Northwest Hockey League season. Unfortunately, both players had their seasons end prematurely within a week of one another in early February. Moffatt was seriously injured in a car accident, and Lyons died unexpectedly. The Orphans played only one more game before bowing out of the league for the balance of the season. (Courtesy of the *Seattle Post–Intelligencer* Collection, Museum of History & Industry.)

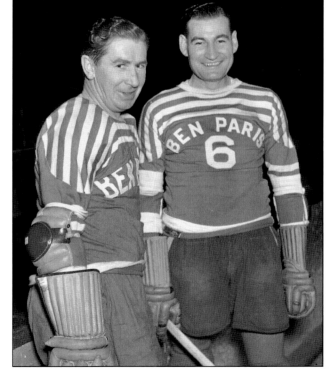

During World War II amateur hockey flourished in Seattle. During the 1942–1943 season the league became known as the Seattle Ice Hockey League and was condensed to three teams: Lake Washington, the Boilermakers, and Boeing. A dozen former professionals, most who had played in Seattle previously, dotted the rosters in what was one of the most competitive seasons in league history. Lake Washington and Boeing were tied at the end of the year with identical 6-5-2 records. Lake Washington won the title on two straight playoff victories over Boeing by scores of 7-5 and 5-3.

The City Hockey League expanded to five teams during the 1943–1944 season and included entries from Vancouver and Portland in addition to three Seattle clubs. Unfortunately the Boeing Bombers (shown here) were not as successful as they had been in the past, finishing in last place with a 5-10-1 record. (Courtesy of the *Seattle Post–Intelligencer* Collection, Museum of History & Industry.)

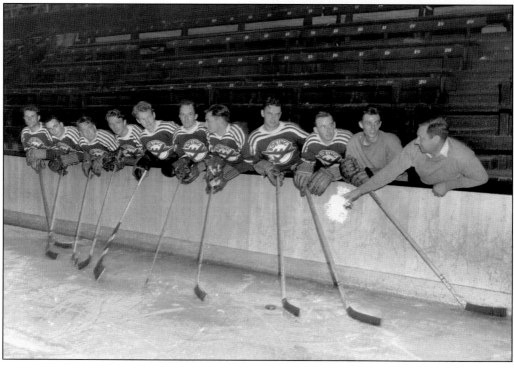

Jim Forsythe was a fixture in the City Hockey League, winning a championship alongside brother Bert with the Shurfine Grocers in 1941–1942. He later moved on to play for teams sponsored by Boeing and Isaacson's Iron Works. During the 1943–1944 season with the Ironmen (shown here) he played alongside Seattle hockey veterans Dave Downie and Vince Abbey. (Courtesy of Dave Eskenazi.)

Isaacson Iron Works, a local construction and shipbuilding company, sponsored the Ironmen beginning with the 1943–1944 season. The Ironmen were one of two City Hockey League teams to make the move to the PCHL, eventually going professional along with the rest of the league in 1948. The team was purchased by former player Frank Dotten in the late 1940s, becoming the Seattle Ironmen. The franchise went through a number of ownership and name changes, eventually becoming the Seattle Totems. It lasted 31 seasons from 1943 through 1975, missing only the 1954–1955 season when the Bombers took a one-year hiatus to deal with financial difficulties. (Courtesy of the *Seattle Post–Intelligencer* Collection, Museum of History & Industry.)

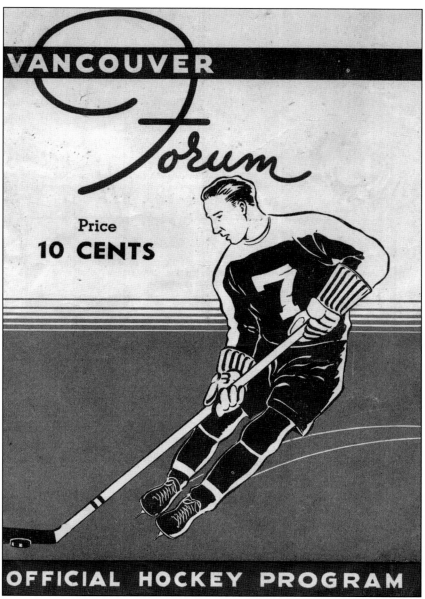

VANCOUVER
Forum

Price
10 CENTS

7

OFFICIAL HOCKEY PROGRAM

The 1944–1945 season was the first for the Pacific Coast Hockey League, which consisted of 10 clubs along the west coast stretching from Vancouver to San Diego. The Northern Division had four teams including two Seattle entries—the Ironmen and the Stars. The Ironmen proved to be the class of the division, finishing the season in first with a 21-6-1 record. Led by Frank Dotten, the Ironmen knocked off Portland in the division finals and earned the right to face the Boston Olympics of the EAHL for the US Amateur Hockey Association championship. The best-of-seven series was split between Seattle and Vancouver. After dropping the first two games in Seattle, the Ironmen won the next four straight to take the championship from the heavily favored Olympics. Dotten scored 13 goals and had six assists in the series to lead all scorers as the Ironmen outscored their opponents 45-24. The program shown is for one of the two games played in Vancouver (games 3 and 4). (Courtesy of Dave Eskenazi.)

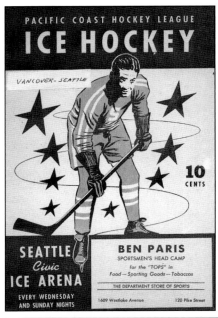

Ironmen manager Frank Dotten pulled off a coup by signing Bill Robinson and Eddie Dartnell, two of the most widely sought amateurs in hockey, for the 1945–1946 PCHL season. The move almost backfired when the two new players, along with Dotten, were suspended by the Canadian Amateur Hockey Association (CAHA) due to a complaint filed by former Seattle Metropolitan Lester Patrick, now the GM of the New York Rangers. Patrick alleged that all three players were on the Rangers protected list and had accepted retainers from the pro club, making them ineligible to play as amateurs. The three were eventually absolved of any wrongdoing. The Ironmen finished the season at 29-29-0 and were eliminated in the playoffs by Portland.

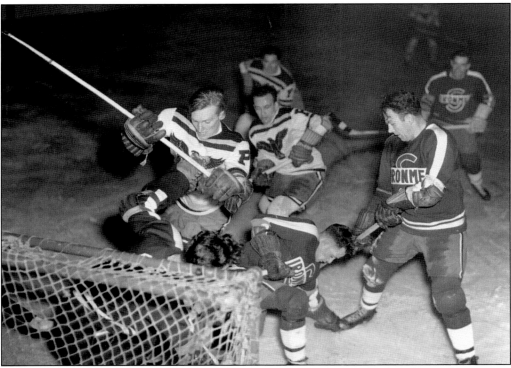

Goaltender Al Rollins of the Ironmen makes a save against the Portland Eagles on the opening night of the 1945–1946 season. Over 5,000 fans packed the Civic Arena to see playing coach Frank Dotten score a hat trick, leading the Ironmen to a 7-3 win. Rollins later went on to a long professional career that included parts of nine seasons in the NHL with Chicago and New York. (Courtesy of the *Seattle Post–Intelligencer* Collection, Museum of History & Industry.)

Frank Dotten purchased the Ironmen prior to the 1946–1947 season, retiring as a player and turning his attention to the management of his club. It was a violent season in the PCHL, punctuated by a number of brawls and serious injuries. A near tragedy struck the league on February 5, 1947, when a train carrying the San Francisco Shamrocks was involved in a fiery crash. The players responded bravely, pulling other passengers out of the fire, but six of the Shamrocks were seriously injured and the team had to borrow players from the rest of the league to finish out the season.

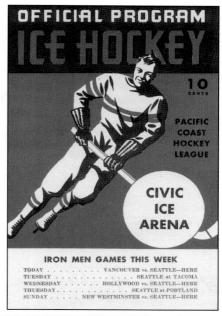

OFFICIAL PROGRAM

ICE HOCKEY

10 CENTS

PACIFIC COAST HOCKEY LEAGUE

CIVIC ICE ARENA

IRON MEN GAMES THIS WEEK

TODAY VANCOUVER vs. SEATTLE—HERE
TUESDAY SEATTLE at TACOMA
WEDNESDAY HOLLYWOOD vs. SEATTLE—HERE
THURSDAY SEATTLE at PORTLAND
SUNDAY NEW WESTMINSTER vs. SEATTLE—HERE

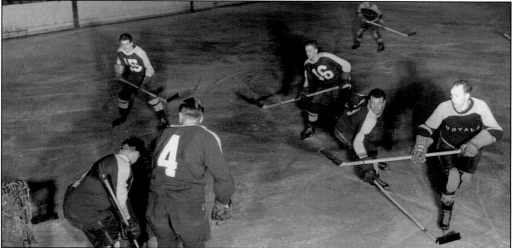

The Ironmen finished the 1946–1947 season second in the Northern Division with a 34-25-1 record. They faced the fourth place New Westminster Royals (29-29-2) in the opening round of the PCHL playoffs. The best-of-five series opened in Seattle as a large crowd watched the Ironmen blow a 4-1 lead, losing the game 5-4 in overtime. They tied the series on a 3-1 win in the second meeting, followed by a rough third game enlivened by a brawl in the penalty box between Bill Robinson of the Ironmen and Bill Sloboda of the Royals. When the smoke finally cleared, Seattle had a 2-0 shutout to take the lead in the series. The Royals were knocked out of the playoffs in the fourth game on a 3-1 loss. In the division finals against Portland, the Ironmen hopes were crushed when starting goaltender Nelson "Freckles" Little was struck in the eye by a puck, knocking him out of the series. Seattle was forced to use City League amateur Craig McClelland for the remainder of the playoffs and never recovered from the loss of their starter, eventually losing the series in six games. (Courtesy of the *Seattle Post–Intelligencer* Collection, Museum of History & Industry.)

After leading the Quebec Aces to the Allan Cup (the amateur hockey championship of Canada) during the 1944–1945 season, Bill Robinson came out west with teammate Eddie Dartnell to spend the next three seasons (1945–1948) with the Ironmen. Robinson, a center, was well known for his scoring prowess and he had 86 goals and 143 assists with the Ironmen. In his first game in Seattle on October 21, 1946, Robinson had his arm broken in two places. Despite sitting out 13 games while his arm mended, he led the team in assists (47) and was second in goals (33) and points (80). In 1958 he was part of the first group of six players selected as members of the Seattle Hockey Hall of Fame.

The 1947–1948 season was the final amateur season of the PCHL. Cy Rouse, shown here on the cover of a program from that season, tied for the team lead with 44 goals during his only year with the Ironmen. The club finished first in the division with a 42-21-3 record. After defeating the New Westminster Royals in the opening round of the playoffs the Ironmen fell to Vancouver, a repetition of so many previous postseason disappointments at the hands of teams from that city.

Walter "Ollie" Dorohoy played 13 seasons as a professional in the PCHL and WHL, 11 of which were spent in New Westminster. The other two seasons, 1947–1948 and 1955–1956, were played in Seattle with the Ironmen and Americans respectively. A small player at 5-foot-8 and 150 pounds, Dorohoy was purchased by the Ironmen for what was reported to be the highest price ever paid for a player in league history. He was a consistent scoring threat at center, netting 34 goals with the team. The bandages shown in the photo cover cuts received from a high sticking incident with Jack Tomson of New Westminster.

The 1947–1948 Seattle Ironmen are pictured, from left to right, as follows: (front row) Cy Rouse, Maurice Marchant, Scoop Bentley, Dutch Evers, and Red Tilson; (middle row) Ron Pickell, Gordie Kerr, Al McFadzen, and Roy McBride; (top row) Eddie Dartnell, Walter Dorohoy, Maurice Duffy, and Bill Robinson. The majority of these players remained amateurs throughout their careers, and none of them ever made it to the NHL.

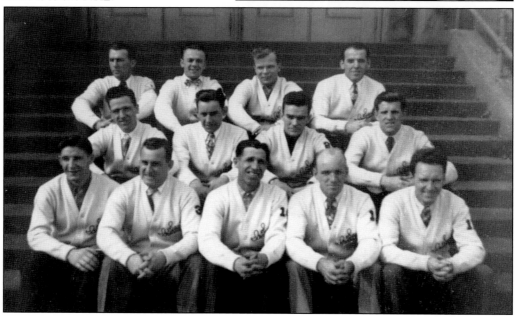

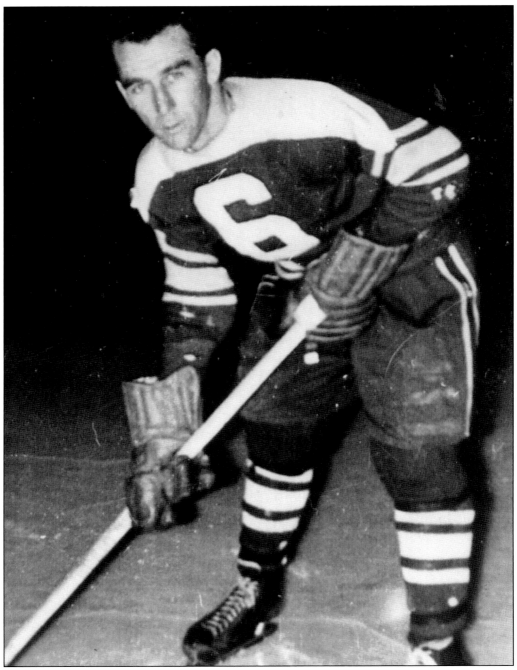

Eddie Dartnell came to Seattle to join the Ironmen in 1945-1946 along with Quebec Aces teammate Bill Robinson. He played alongside Ironmen manager Frank Dotten in 1940-1941 when the pair were members of the New York Rovers of the EHL. He led the club in goals (42) and points (83) in 1945–1946. While his production decreased after that, he still managed to score 103 goals and 215 points during his three seasons in Seattle from 1945–1948. Dartnell was one of the original six inductees into the Seattle Hockey Hall of Fame in 1958.

FOUR

The Professional Game Returns (1948–1958)

On January 14, 1948, the franchise owners of the Pacific Coast Hockey League (PCHL) met in San Francisco to discuss the future of the league. The Southern Division teams (all located in California) had lobbied for the league to turn professional for a number of years, but the Northern Division clubs (all located between Vancouver and Portland) were against the change because it had serious tax implications for the Canadian entries. However, over time it became clear that the only way to put good teams on the ice on a consistent basis was to make the PCHL a professional circuit, giving owners control over their players through the reserve clause. They held a vote at the end of the meeting, and it was decided that the PCHL would become professional for the 1948–1949 season. Professional hockey was returning to Seattle.

Ironmen owner Frank Dotten had to put together an almost entirely new club for the 1948–1949 season. Only four players from the previous year were signed to professional contracts, so Dotten had his work cut out for him. One of his most astute moves was the signing of 21-year-old center Rudy Filion, an amateur who played previously with the Tacoma Rockets. Filion went on to play 14 consecutive seasons in Seattle and was one of the key figures in the process of building a competitive club, bridging the gap between the amateur game and the glory years of the 1960s.

While the Northern Division remained strong, the Southern Division struggled and eventually disbanded following the 1949–1950 season. To compensate for the loss of the California teams, the league expanded into the Canadian prairies by adding teams in Calgary, Edmonton and Saskatoon for the 1951–1952 season. Due to the franchise changes, the PCHL changed its

name to the Western Hockey League (WHL) in 1952 to better represent the make-up of the league. In Seattle, Dotten also changed the name of his team. They would now be known as the Seattle Bombers.

The Bombers were no better than their predecessors, and their struggles on the ice were mirrored by struggles at the gate as the average attendance dropped to around 2,000 fans per game. After a fifth place finish in the eight-team league in 1952–1953, the Bombers fell into the cellar the following season with a 22-41-7 record despite having the league's top goal scorer in Wayne Brown (49 goals). Other than Brown, the only bright spot in an otherwise dismal season was the play of a promising young center in his first season with Seattle, a player who would go on to break most of the league scoring records and become an icon in Seattle sports: Guyle Fielder.

The Bombers' financial struggles prompted Dotten to request a one-year leave of absence for the club. League president Al Leader reluctantly agreed and the team sat out the 1954–1955 season. But Leader was concerned about the prospect of losing the only American based team in the league, and when Dotten was unable to get his finances in order the league took over the franchise, selling it to local television executive Bill Veneman. Veneman didn't know a lot about hockey, but he did know advertising and promotions. He also knew something about sports—his television station KTVW broadcasted the games of the Seattle Rainiers baseball club. He budgeted $125,000 for operations and promotions, and hired a high profile coach in Bill Reay, a veteran of eight seasons with the Montreal Canadiens. Veneman also gave the team a new name, one better reflecting its place in the WHL—the Seattle Americans.

During the team's hiatus, its players were signed by other clubs throughout the league. Many, including Fielder and Filion, were returned to the Americans to rebuild the franchise. Reay proved to be a good judge of talent, acquiring a number of excellent players including veteran forwards (and brothers) Eddie and Ollie Dorohoy, as well as a pair of promising newcomers in Val Fonteyne and Gordie Sinclair, both of whom would be important parts of the franchise. Reay also used his connections with the Canadiens to get Jack Bownass and goalie Charlie Hodge assigned to Seattle. Though the club had a lot of potential, they struggled through the 1955–1956 season and finished last in the four-team Coast Division. Reay was replaced by former defenseman Keith Allen who would lead the club for the next nine seasons and bring stability to a franchise that had seen seven different coaches in seven years.

In Allen's first season as coach the Americans went from worst to first, finishing atop the standings in the Coast Division with a 36-28-6 record. They were led offensively by Fielder, Fonteyne and Ray Kinasewich, who combined to form the highest scoring line in the league. Fielder set the single season league records for assists (89) and total points (122), the first of four consecutive seasons in which he led the WHL in these categories. He also earned his first of four consecutive Most Valuable Player awards. A late-season shoulder injury to goalie Emile "The Cat" Francis contributed to quick departure from the playoffs, but the success of the regular season was a sign of things to come. The additions of Bill MacFarland and Don Chiupka the following season solidified the team, and though the Americans finished with a .500 record (32-32-6) their first round playoff series win over New Westminster was the first postseason success for a Seattle team since 1948.

While the Americans continued to come together on the ice, attendance remained inconsistent and Veneman wanted out. When he purchased the team Veneman told Leader that if he couldn't build the Americans into a successful business in three years, it would prove that Seattle was not a hockey town. The team still was not a financial success and for the second time in three years Leader had to find a buyer for the franchise. This time he put together a 12-man ownership group to purchase the club in the summer of 1958. Little did Veneman know that the team was on the verge of its greatest period of success both on the ice and at the gate, as the newly named Totems would win three league titles over the next 10 seasons and witness the opening of the new 12,000-seat Seattle Coliseum, ushering in the "Golden Age" of hockey in Seattle.

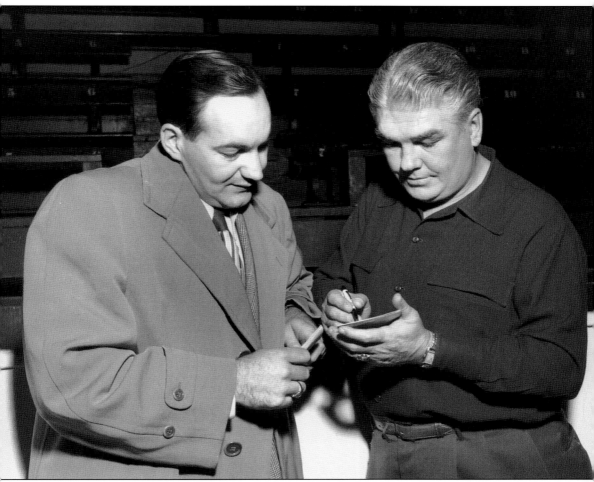

Frank Dotten (left) first appeared on the Seattle hockey scene during the 1944–1945 season, joining the Ironmen as a playing coach. He paced the team in scoring that season with 38 goals and 72 points in only 27 games, and led them to the US Amateur Hockey Association championship by scoring 14 goals in the finals against Boston. He played one more season with the Ironmen before purchasing the club prior to the start of the 1946–1947 season. During his eight seasons as owner, Dotten transformed the club from amateur to professional in 1948, and later changed the team's name to Bombers prior to the 1952–1953 season. While he had a good eye for talent, Dotten was tough boss and known for firing coaches on a regular basis. Under his reign the team had moderate success on the ice (one first place finish, no championships) but constantly struggled at the gate. Dotten requested a one-year leave of absence from the league during the 1954–1955 season, but when he was still unable to get his finances in order the Bombers were taken over by the league and sold. Dave Downie (right) was a solid forward for the Seahawks and Olympics from 1936 to 1941, leading the team in scoring three times and leading the league in goals (35) in 1938–1939 and points (48) the following season. He played two seasons in the City Hockey League during World War II, topping the circuit in goals (19) in 1943–1944. Downie returned to Seattle as a coach under Dotten from 1948 to 1950 before pressure from the fans, who were upset by the team's poor performance, forced his resignation in February of 1950. (Courtesy of the *Seattle Post–Intelligencer* Collection, Museum of History & Industry.)

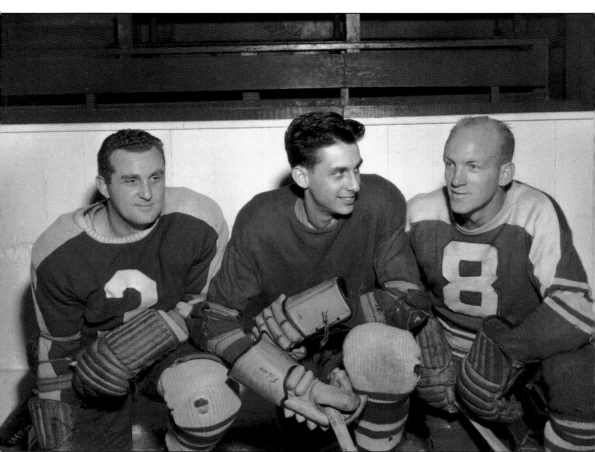

Rudy Filion (center) was a 21-year-old amateur when Frank Dotten signed him to go pro with the Ironmen for the 1948–1949 season. It turned out to be one of the most significant signings in Seattle hockey history. Filion went on to play 14 consecutive seasons in Seattle and is second all-time in number of regular season games played in the city with 887. He was consistently one of his team's top scoring threats, averaging 22 goals per season. Filion was also known for playing a clean game, only picking up 82 penalty minutes over those 14 seasons, an average of about one two-minute penalty every 20 games. He was the one constant in a sea of changing players during the late 1940s and '50s. This photo was taken during Ironmen training camp in October of 1948, before Filion's first professional game had been played. Alongside Rudy are Maurice "Butch" Marchant (left) and Dutch Evers (right). Marchant led the Ironmen in penalty minutes the previous season with 166, but left the club prior to the start of the 1948–1949 season and ended up in the IHL. Evers was starting his second season with the Ironmen, but would later be traded to New Westminster. (Courtesy of the *Seattle Post–Intelligencer* Collection, Museum of History & Industry.)

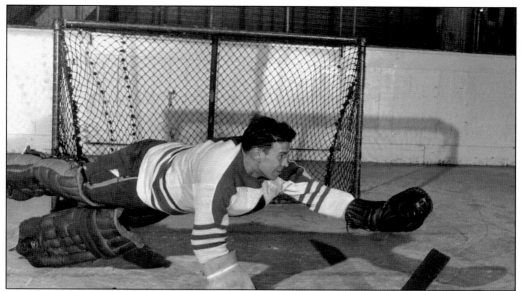

Jerry Cotnoir played in parts of three seasons with the Ironmen from 1948 to 1951, compiling a 39-48-8 record. On December 11, 1948, he took a puck to the face in the third period of a game against Tacoma, knocking out two of his teeth and loosening a number of others. Cotnoir stayed in the game, which was tied 6-6 at the time, playing out the rest of the period and all of the overtime as the Ironmen came away with a 7-6 win. He spent the start of the 1949–1950 season on loan to New Westminster, but was recalled to Seattle when the Ironmen traded away their starter, Ron Pickell. He finished out the year and started the following season with the Ironmen, but his inconsistent play and 4.15 GAA through the first nine games of the 1950–1951 season cost him his job. He was sent to Victoria where he played out the season. (Courtesy of the *Seattle Post–Intelligencer* Collection, Museum of History & Industry.)

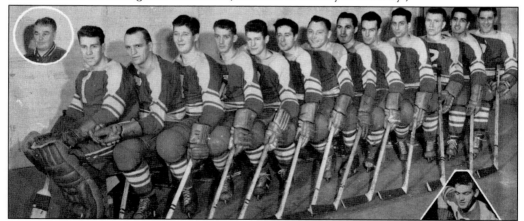

The PCHL transitioned from amateur to professional for the 1948–1949 season, and the Ironmen became the first pro team to play in Seattle since the 1940–1941 Olympics. They finished the season in the cellar of the North Division with a 29-36-5 record. Team members, shown here from left to right, included (seated) Jerry Cotnoir, Willie Schmidt, Bob Gibson, George Hayes, Pete Taillefer, Pete Kalapaca, Paul Waldner, Joe Medynski, Al McFadzen, Rudy Filion, Gordie Kerr, Fred Valenti, and Jack Tomson. The two insets show coach Dave Downie (upper left) and George Senick (lower right).

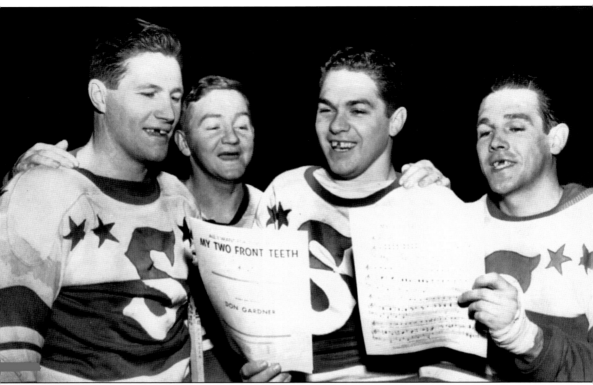

This great photo from the winter of 1951 shows four members of the Ironmen, without their dentures, singing "All I Want for Christmas is my Two Front Teeth." Pictured, from left to right, are Stan Maxwell, Freckles Little, Jack Jackson and Joe Bell. Bell led the team in scoring in 1951–1952 with 38 goals and 69 points, his second consecutive season leading the squad. Over a four-year career in Seattle from 1950 to 1954 Bell averaged 33 goals per season, and his 46 goals in 1950-1951 led the entire PCHL. As well as things were going for Bell, Jackson was heading in the opposite direction. The 26-year-old defenseman, playing his first season in Seattle, prematurely ended own career by suggesting during a team meeting that the fifth place Ironmen would be better served by intentionally losing games to drop to sixth in the standings. He reasoned that since the winner of the opening round playoff series between the sixth place team and the first place club received a bye in the second round, going straight to the league finals, they could thereby reduce the number of games the team needed to play to win the championship. His suggestion did not go over well and he was immediately suspended by the Ironmen and the league. In addition, the Cleveland Barons, who owned Jackson's rights and were loaning him to Seattle, immediately paid off his contract and sent him packing. It was the last that anyone ever heard of Jack Jackson in professional hockey. (Courtesy of AP/WORLD WIDE PHOTOS.)

The Ironmen played their home games in the Civic Arena, usually to a building that was only about half full. That being said, the fans were rabid and altercations between fans and players were not uncommon. Sometimes tempers flared to the point where a full-scale riot broke out, as happened on December 14, 1947, when an estimated 300 fans stormed the ice in response to a bench-clearing brawl that broke out after the final buzzer.

The PCHL was renamed the Western Hockey League prior to the start of the 1952–1953 season, and Frank Dotten followed suit by renaming his club the Seattle Bombers that same year. Unfortunately the name change didn't do anything to help the quality of the team on the ice, and the only place they bombed was in the standings. They finished fifth in 1952–1953 and dropped into the cellar in 1953–1954 with a dismal 22-41-7 record.

The 1953–1954 Bombers invited two black players to training camp, forward Alf Lewsey and defenseman Bill Geary. Both played in the September 27 exhibition loss to the New York Rangers of the NHL, and Lewsey also appeared in a pre-season game played in Spokane on October 4. Neither player made the final roster, nor did they appear in any regular season games. One player who did make the team was a newcomer by the name of Guyle Fielder, who was on loan from the Detroit Red Wings. Fielder picked up a goal and an assist in his first game with the Bombers on October 10, 1953, the first of over 1,400 regular season points he would score in a Seattle uniform.

When Bombers owner Frank Dotten was unable to get his finances in order following a one-year hiatus from the league, the WHL took over the Bombers and league president Al Leader arranged for the sale of the club to local television executive Bill Veneman (seated). Veneman renamed the team the Americans and spent the next three seasons (1955–1958) trying to make the franchise a financial success. Under his ownership the team steadily improved on the ice but continued to struggle at the gate. Frustrated by his inability to draw fans on a consistent basis, Veneman put the team up for sale during the summer of 1958, convinced that hockey could not be financially successful in Seattle. (Courtesy of the *Seattle Post–Intelligencer* Collection, Museum of History & Industry.)

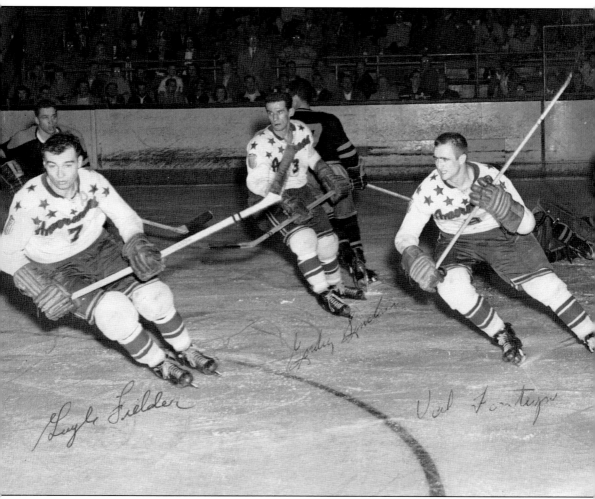

Three of the greatest players ever to suit up in Seattle: Guyle Fielder (left), Gordie Sinclair (center) and Val Fonteyne (right). Fielder joined the Bombers during the 1953–1954 season, the first of 14 he would play in Seattle. During that time he broke almost every offensive record in the WHL, winning six MVP awards in the process. Line-mate Val Fonteyne had four great years in Seattle from 1955 to 1959, averaging 27 goals per season, before embarking on a 15-year career in the NHL and WHA. Defenseman Gordie Sinclair patrolled the blueline in Seattle for 11 seasons and was known primarily as a skill player, moving the puck well and averaging 32 assists per season. The three played together for four seasons from 1955 to 1959, helping the Americans and Totems to two first place finishes and a WHL championship in 1959.

Val Fonteyne spent four seasons in Seattle between 1955 and 1959, missing only six games over that period. He was a division all-star in 1958 and 1959 and was a key to the offense, playing on the left wing alongside Guyle Fielder. Fonteyne was known for his clean style of play—he appeared in all 70 games during the 1955–1956 season without taking a single penalty, and only picked up 19 penalty minutes while with Seattle. Fonteyne played in 820 NHL games with Detroit, New York, and Pittsburgh.

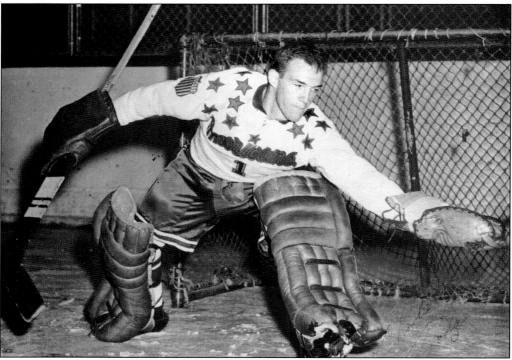

Charlie Hodge was loaned to Seattle by Montreal during the 1955–1956 season, largely due to the influence of Americans coach Bill Reay, who had spent eight years with the Canadiens organization. Hodge went 31-37-2 with the Americans, earning six shutouts and posting a solid 3.38 GAA. He also proved to be a workhorse, playing every minute of every game. Reay left the team following the season, and Hodge was reassigned by Montreal. He played in parts of 13 NHL seasons with Montreal and Oakland, compiling an impressive 151-124-61 record.

Eddie Dorohoy had a long and successful hockey career in the west, playing 15 seasons in the PCHL, WHL and WIHL. He was loaned to the Americans by the Montreal Canadiens for two seasons from 1955 to 1957. Dorohoy was second in scoring on the team each season, behind only perennial scoring leader Guyle Fielder. He played on a line with his brother Walter (known as "Ollie") during the 1955–1956 season, the only time the brothers played together as professionals. Their line, which included Alex Kuzma, scored 58 of the team's 201 goals that season as the Americans finished last in the Coast Division.

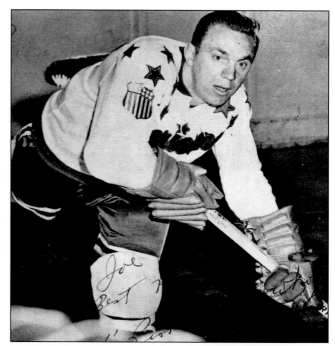

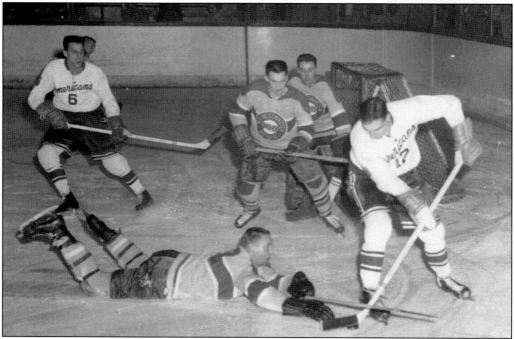

Alex Kuzma (right, wearing No.12) digs the puck free in the corner as Rudy Filion (left, wearing No. 6) looks for the pass in front of the net. Kuzma played three solid seasons in Seattle from 1955 to 1958 before being traded to Vancouver for Jim Powers on November 24, 1958. Powers was excellent in Seattle, picking up 26 goals in 56 games that season as the Totems went on to win the WHL championship in the spring of 1959.

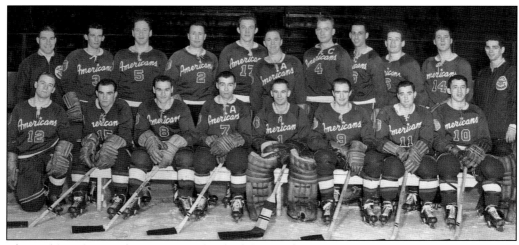

The 1956–1957 Seattle Americans finished first in the Coast Division with a 36-28-6 record. They were the top-scoring team in the WHL, lighting the lamp 263 times. Starting goalie Emile "The Cat" Francis played the first 68 games of the season without incident before separating his shoulder in the second to last game of the season. Though he only missed two games as a result of the injury, he was not at 100 percent and the Americans bowed out in the first round of the playoffs. The 1956–1957 Americans, pictured from left to right, are (front row) Alex Kuzma, Art Hart, Ray Kinasewich, Guyle Fielder, Emile Francis, Val Fonteyne, Bart Bradley, and Norm Lenardon; (back row) George Senick, Gordie Sinclair, Fred Creighton, Keith Allen, Bruce Lea, Eddie Dorohoy, Pete Wright, Rudy Filion, Lionel Repka, Max Szturm, and Don Hamilton.

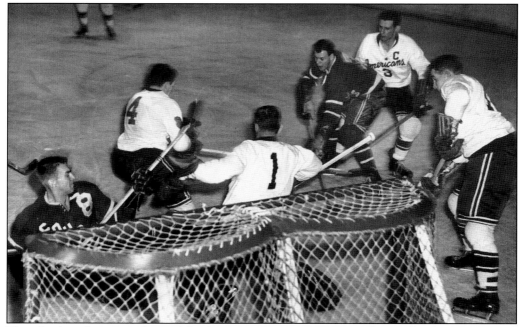

There's a lot of action in front of the Americans' net as captain Gordie Sinclair (wearing No. 3) and teammates try to clear the puck. The Americans registered a 99-97-14 record from 1955 to 1958, with one first place finish and one season in the cellar.

Goaltender Emile "The Cat" Francis (left) and forward Val Fonteyne (right) pose for a photo during the 1956–1957 season. Fonteyne picked up 24 goals and 64 points for the Americans that year, fourth best on the team. It was Francis' only season in Seattle as a regular (he played one game as an emergency backup in 1960), and his 3.14 GAA and four shutouts were good enough to earn him a spot as a second team all-star. He went on to play in parts of six seasons in the NHL with Chicago, and his later work as a coach and manager earned him a place in the Hockey Hall of Fame in 1982.

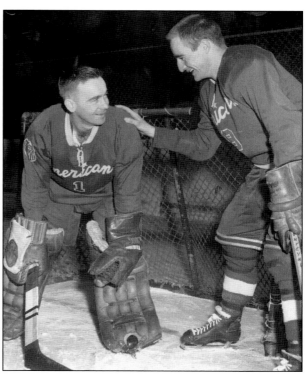

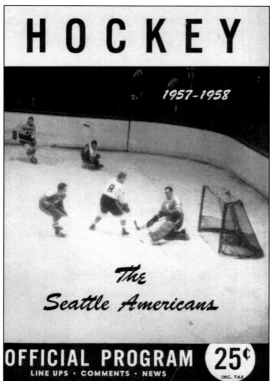

Expectations were high going into the 1957–1958 season—after all, the Americans had finished in first place the previous year with the best offense in the league. Things looked even better when Guyle Fielder was retuned to the club after a tryout with the Detroit Red Wings early in the season. Unfortunately the team just didn't gel and only managed a 32-32-6 record, good for third in the four team Coast Division. They won their first round playoff series against New Westminster, the first postseason series win for the franchise since 1948, but were eliminated in the following round by Calgary.

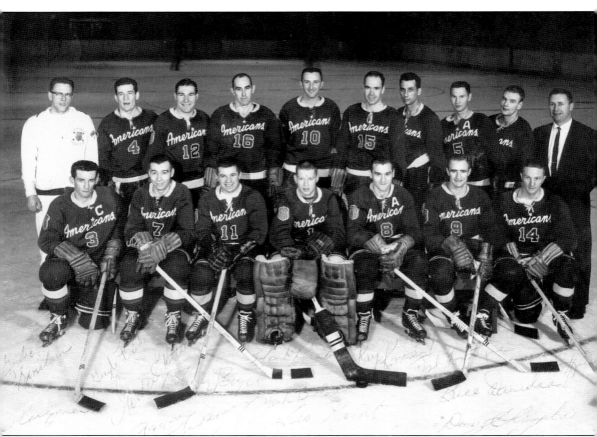

Eight members of the 1957–1958 Americans (Fielder, Fonteyne, MacFarland, Filion, Chiupka, McVie, Sinclair and Hunt) would return to Seattle the following season, forming the nucleus of one of the best teams in the city's history. The 1957-1958 team, pictured from left to right, included (front row) Gordie Sinclair, Guyle Fielder, Gordon Tottle, Hank Bassen, Ray Kinasewich, Val Fonteyne, and Don Chiupka; (back row) Dick Bielous (trainer), Alex Kuzma, Adolph Kukulowicz, Nelson "Blinky" Boyce, Les Hunt, Bill MacFarland, Rudy Filion, Bill Davidson, Lionel Repka, and Keith Allen (coach).

FIVE

The Totems (1958–1975)

Just as Veneman changed the name of the Bombers to Americans when he purchased the team in 1955, the new owners of the franchise decided a name change was in order. The new team was to be known as the Jets, a reference to Seattle's nickname of "Jet City" derived from the presence of the Boeing aircraft facilities. Letterhead was made up and the team was moving forward with the new moniker until Hy Zimmerman, a local sportswriter, suggested that the team should be called the "Totems" in tribute to the strong Native American influence throughout the entire Pacific Northwest region. The name "Jets" was scrapped, and the team was known as the Seattle Totems for the next 17 seasons.

The first season under the new owners in 1958–1959 turned out to be the best in franchise history. The Totems cracked the 40-win barrier for the only time ever, finishing first in the Coast Division with a 40-27-3 record. They were dominant in the playoffs, going 11-1 in the postseason and sweeping the Calgary Stampeders in the WHL finals. It was the start of a decade of excellence during which the Totems made it to the league finals five times from 1958 to 1968, winning three titles, including back-to-back championships in 1967 and 1968. Two players were on all three championship squads: superstar and perennial scoring leader Guyle Fielder, and a scrappy center named Gerry Leonard. One other person was with the club for all three championships—Bill MacFarland. MacFarland was a high scoring forward in Seattle from 1957 to 1966, after which he hung up his skates and stepped behind the bench to take over as head coach and general manager prior to the 1966–1967 season. He led the Totems to championships during his first two seasons as coach, and went on to become the president of the WHL and later of the World Hockey Association.

The Totems played in the old Civic Arena through the end of the 1963–1964 season, after which they moved into the brand new Coliseum just a few blocks away. Built as part of the 1962 World's Fair in Seattle, the new multi-purpose facility could seat over 12,000 fans for hockey and became the permanent home of the Totems starting in the fall of 1964. The first sporting event held in the new building was an exhibition game between the Totems and the

Toronto Maple Leafs on September 30, 1964. A crowd of 8,601 turned out in full evening wear, including some in tuxedos and top hats, to watch the Leafs defeat the Totems by a score of 7-1. The Totems played in front of some large crowds in the new building, the biggest of which was a packed house of 13,563 who watched the them fall to the Portland Buckaroos by a score of 5-4 on January 23, 1965.

Following the 1967–1968 championship season the team went into decline. They were eliminated in the first round of the playoffs in 1970, and never again appeared in the postseason. The team's winning percentage slowly declined each year until the bottom finally dropped out in a disastrous 1971–1972 season that saw the Totems go 12-53-7, the worst record in the history of the WHL. By then the team was operating under a working agreement with the Vancouver Canucks of the NHL, an expansion franchise that was struggling in its own right. Players were constantly being cycled in and out of Seattle, and it was almost impossible for the club to put together a cohesive and consistent team. Due to financial difficulties following on the heels of the Totems' decline on the ice, the Canucks purchased an interest in the club to help ensure that it would remain in Seattle as a farm team.

The Totems rebounded from the awful 1971–1972 season and put together a competitive team the following year. The highlight came on Christmas Night, 1972 when the Totems hosted the Russian national team in an exhibition game at the Coliseum. The Russians were getting ready for the upcoming World Cup tournament in Minnesota, and Seattle was the first stop on their four game swing through the WHL. The Russians had a formidable lineup that included eighteen players who had participated in the Summit Series against Canada a few months earlier, barely losing an eight game series against the top Canadian professionals. Over 12,000 fans turned out to watch. The Totems kept it close for two periods before the Russians took over in the third, eventually winning by a score of 9-4. The Soviets went on to win all four games against the WHL teams, all in front of packed houses. The series was such a success that it was repeated the following year, and this time the tour included the World Cup entry from Czechoslovakia. The Czechs arrived first and met the Totems on Christmas Night, 1973. After falling behind 3-0, the Totems began playing a more physical game and took control, eventually coming away with a 6-4 win. The Russians arrived a little over a week later, having already defeated Phoenix, Portland and San Diego. The game against the Totems on January 5, 1974 was their last exhibition. In front of a sold out crowd in the Coliseum the Totems pulled off an improbable upset, knocking off the Russians 8-4 on a hat trick by Don Westbrooke.

The win against the Russians was the last hurrah for the Totems. The WHL folded following the 1973–1974 season, and the team joined the Central Hockey League for the 1974–1975 campaign. Seattle had been promised an NHL expansion team, and the owners were trying to keep the team afloat long enough to join the NHL. When the expansion franchise never materialized, the Totems folded in the summer of 1975 and the owners filed an anti-trust lawsuit against the NHL, which dragged on through the courts for over a decade before finally being settled. Professional hockey had again left Seattle, and this time there wasn't a new team on the horizon.

Totems coach Keith Allen established a working agreement with the Detroit Red Wings in the late 1950s, allowing him to obtain players on loan from the NHL club. One of those players was Marc "The Shark" Boileau, who first came to Seattle for the 1958–1959 season. He played three seasons with Seattle from 1958 to 1961 before making the jump to the NHL, appearing with Detroit in 1961–1962. He returned to the minors after that, and eventually landed back in Seattle for another three seasons from 1967 to 1970. He won WHL championships with the Totems in 1959 and 1968, and in 1959–1960 he was part of the highest scoring line in the league, skating alongside Bill MacFarland and Rudy Filion.

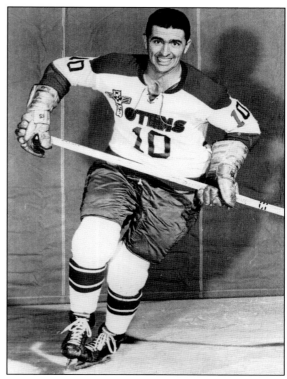

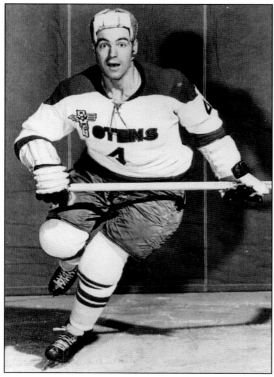

Frank "Crash" Arnett was a tough and rugged defenseman with the Totems for four seasons from 1958 to 1962. He led the WHL in penalty minutes during his first two years with the club, setting the (then) league record with 210 minutes in 1958–1959. His most celebrated incident took place in Seattle on December 27, 1959. Portland Buckaroos coach Hal Laycoe threw his hat on the ice in protest of a penalty call, and Arnett took it upon himself to stickhandle the hat around the ice before finally crushing it with his skate, which led to a brawl between the two teams. It was the second time in less than a month that Arnett had pulled the same stunt with an opposing coach's hat.

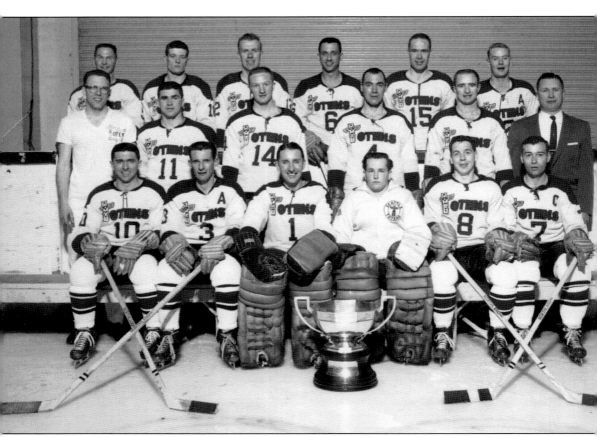

The 1958–1959 Totems were one of the best teams ever to take the ice in Seattle. They were the top offensive club in the WHL, scoring 277 goals and finishing first in the Coast Division with a 40-27-3 record. Guyle Fielder led the league in assists (95) and points (119) for the third consecutive year on the way to his third straight MVP award. After defeating Victoria and Vancouver in the first two rounds of the playoffs, the Totems moved on to the WHL finals against the Calgary Stampeders, owners of the best record in the Prairie Division. They won the first two games in Calgary, then returned to Seattle to complete the four game sweep. They went 11-1 in the playoffs and won their first WHL championship, the first title for a Seattle club since 1945. The 1958–1959 Totems are shown here, from left to right, as follows: (front row) Marc Boileau, Gordie Sinclair, Bev Bentley, Billy Tibbs, Tom McVie, Guyle Fielder; (middle row) Dick Bielous (trainer), Dave Rimstad, Don Chiupka, Frank Arnett, Val Fonteyne, Keith Allen (coach); (top row) Bill Davidson, Gerry Leonard, Jerry Goyer, Rudy Filion, Bill MacFarland, and Les Hunt.

Nobody deserved the WHL championship in the spring of 1959 more than Rudy Filion. He was finishing his ninth season in Seattle and was still a consistent scoring threat, netting 30 goals for the league's best offense. Though he made two more trips to the finals with the Totems in 1961 and 1963, this was his only championship. After retiring as a player in 1966 he moved to the Totems front office to continue his association with hockey in Seattle.

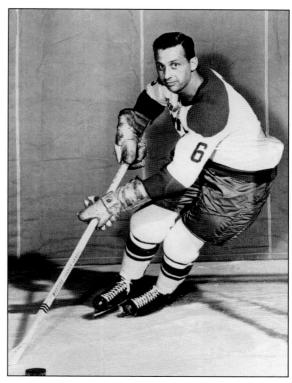

Bill MacFarland (in white wearing No. 15) goes hard to the net against Saskatoon during the 1958–1959 season. MacFarland led the club with 35 goals and was the team's third highest scorer. He also lit the lamp six times during the playoffs, and his 17 postseason points were the second most on the team. He played on a line with Rudy Filion and Don Chiupka which combined for 91 goals, making it the top scoring unit on the Totems.

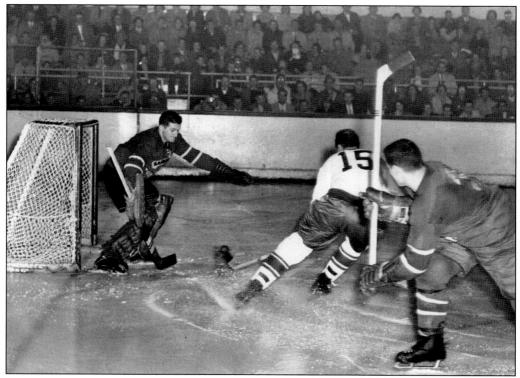

Goaltender Bev Bentley was acquired by the Totems prior to the 1958–1959 season and played between the pipes in Seattle for three seasons, earning a 104-98-12 record with six shutouts. He is second all-time in wins for a Seattle netminder behind Emmett Venne (106). Bentley is shown here wearing an experimental Louch goalie mask circa 1960. He had been struck in the eye by the stick of defenseman Les Hunt and wore the mask during practice for additional protection, though he never wore it in a game.

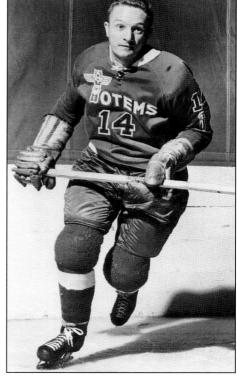

Don "Chips" Chiupka played seven seasons in Seattle from 1957 to 1964. Injuries were Chiupka's worst enemy—a separated shoulder in the spring of 1959 caused him to miss six playoff games, a broken finger in 1960 kept him out of the entire postseason, and a broken jaw in 1962 sidelined him for a month. Despite the frequent injuries, he was a hard-nosed player who could skate on either the checking or scoring line with equal ease.

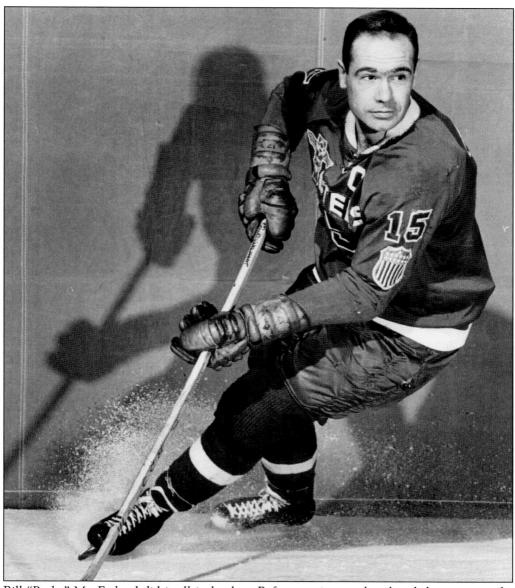

Bill "Packy" MacFarland did it all in hockey. Before turning pro he played three seasons for the University of Michigan, winning the NCAA hockey championship in 1955 and 1956 and being named to the 1955 NCAA Frozen Four All-Tournament Team. He went pro with the Edmonton Flyers in 1956–1957 and was reassigned to Seattle the following season, where he played for the next nine years. His 46 goals in 1961-62 led the WHL, earning him the league's MVP award. He ranks third all-time among Seattle players in goals (299) and points (643), and his 626 regular season games are sixth best. During the off-season Packy studied law, and he was admitted to the Washington State Bar Association in 1964. He was also active in player's affairs, helping to establish the WHL pension fund. MacFarland moved behind the bench as coach and general manager of the Totems from 1966 to 1970, winning back-to-back WHL championships in 1966 and 1967. He served as WHL President from 1971 to 1974, and later as the president of the World Hockey Association from 1975 to 1977.

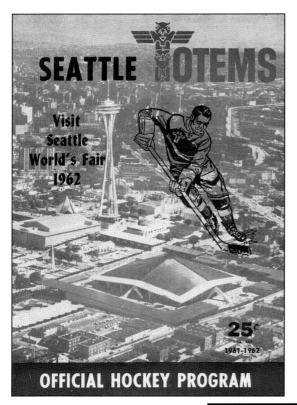

The 1962–1963 Totems finished the season in second and made it to the league finals against the San Francisco Seals. Due to scheduling conflicts in the Civic Arena, the entire series had to be played in San Francisco. Despite the handicap, Seattle roared out to a commanding three games to one lead before collapsing, losing the final three meetings and the series. Four of the seven games, including the seventh and deciding contest, went into overtime. The program for the 1962–1963 season (shown here) includes a photo of Seattle Center, prominently featuring the new Coliseum built for the 1962 World's Fair. The Coliseum would become the home of the Totems starting in the fall of 1964.

The 1957–1958 Americans were the first Seattle hockey club to broadcast their games on the radio, and Bill Schonely was the voice of the team. Schonely called Americans and Totems games for 11 seasons, including all three WHL championships. He opened broadcasts with his trademark line, "Good evening hockey fans, wherever you may be." Schonely once convinced coach Keith Allen to allow him to play as back-up goaltender during a Totems scrimmage (shown here). During the warm-up skate he tripped on the stick of Les Hunt, falling to the ice. Though he gamely continued with the scrimmage, a subsequent visit to the doctor revealed torn muscles in his shoulder, effectively ending his "career" as a player.

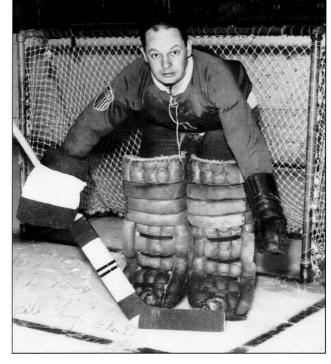

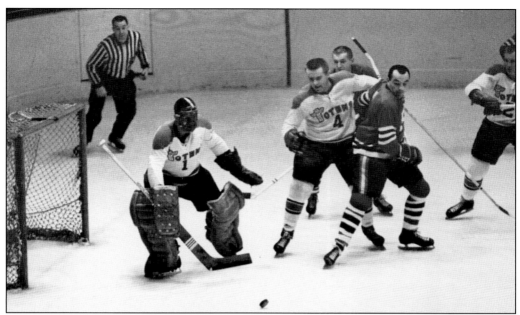

Al Millar (wearing No. 1) was the first goaltender in Seattle history to wear a mask during a game. Millar played two seasons with the Totems from 1961 to 1963, compiling a 65-56-7 record and earning the WHL Outstanding Goaltender award in 1962. In addition to being a solid netminder, he was also willing to mix it up in front of the net and picked up 45 penalty minutes with Seattle. Trying to clear the slot is Jim "Red Eye" Hay (wearing No. 4), a tough defenseman who played with the Totems from 1962 to 1964. By the time he arrived in Seattle, Hay was already a veteran of seven WHL seasons and 74 NHL contests. Totem fans best remember Hay for the five subsequent seasons he spent with the arch-rival Portland Buckaroos.

The WHL held six all-star games between 1958 and 1963. The format varied, sometimes with the league's two divisions competing against one another and at other times a league all-star squad played against an established team. Guyle Fielder appeared in all six contests as a Totem, with Gordie Sinclair joining him on the squad five times. Fielder was the top scorer among Seattle players, picking up two goals and four assists in those six games. The last all-star game took place on September 29, 1963 (program shown here) when the WHL all-stars faced the Toronto Maple Leafs. The defending Stanley Cup champs shut out the all-stars by a score of 3-0. (Courtesy of Johnnie Jones.)

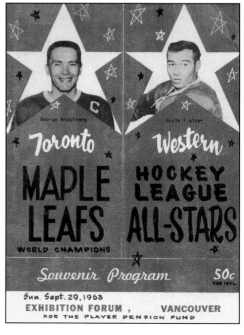

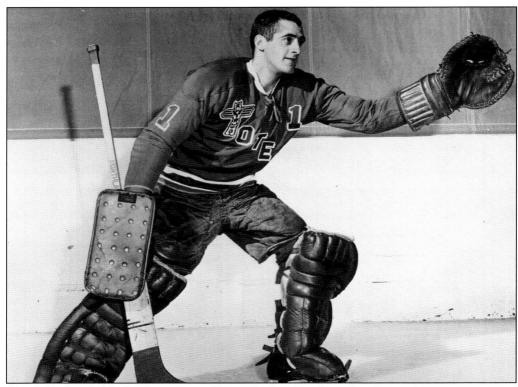

Claude Dufour holds the distinction of being the last Seattle goaltender to play every minute of every game (except for when he was pulled for an extra attacker) over the course of an entire season. He accomplished the feat in 1963–1964, playing in all 70 of the Totems' games. He put together a 29-35-6 record with a 3.19 GAA during his only season in Seattle. Prior to Dufour, the last goalie to play in every game for Seattle was Charlie Hodge during the 1955–1956 season.

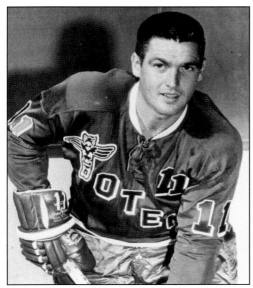

Bob Barlow was the leading goal scorer for the Totems during his three seasons with the club from 1962 to1965. He averaged 37 goals per season in Seattle, and his 47 goals and four hat tricks in 1962–1963 led the league. Barlow and Jim Powers were the wingers on Guyle Fielder's line, and the trio made up the top-scoring unit in the WHL in consecutive seasons between 1962 and 1964.

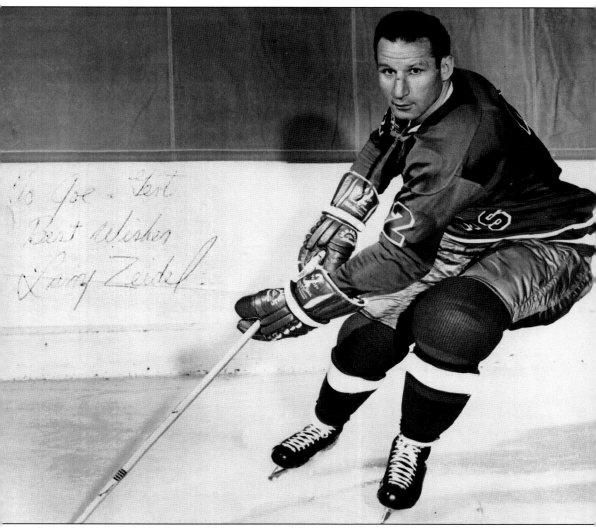

Larry "Rock" Zeidel had one of the most colorful and troubled careers in the history of Seattle hockey. Before coming to the Totems in 1963 Zeidel was a fixture with the Hershey Bears, playing there for eight seasons and becoming the AHL's all-time leader in penalty minutes. He also spent some time in the NHL, winning a Stanley Cup with Detroit in 1952. The 5-foot-11, 185-pound defenseman led the Totems in penalty minutes during both of his seasons with the team and was involved in a number of infamous incidents. During the 1963–1964 season he nearly got into an altercation with former Totem goaltender Al Millar, then with the Denver Spurs, when both insisted on being the last player off the ice at the end of a period. Later in the same game, after taking his fourth penalty, the Rock threw the penalty box bench onto the ice. During that same season he was involved in vicious stick fight with Willie O'Ree of the Los Angeles Blades, earning a four game suspension and a $100 fine. The following year he was involved in one of the ugliest incidents ever on Seattle ice when he tried to spit on referee Willie Papp during the third period on January 17, 1965. Zeidel was suspended five games, fined $200, and forced to put up a $500 bond to ensure future good behavior. He was shipped back to the AHL the following season, but managed to make it back to the NHL two years later, playing parts of two seasons with the expansion Philadelphia Flyers.

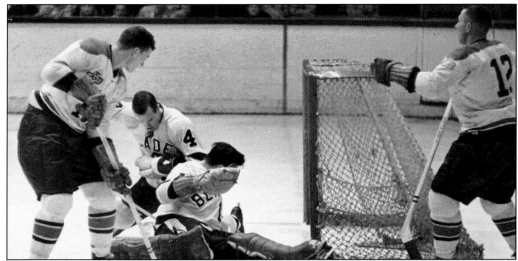

The Totems try to score against the Los Angeles Blades during a game in the early 1960s. Life in the minors was hard in the 60s. The WHL's minimum salary for rookies was only $3,500 per year, with most veterans earning around $4,000 to $7,000 annually. The top stars topped out around $12,000. The modest salaries forced most players to work in the off-season, and also made postseason bonus money all the more important. A player on a first place club that won the league championship could earn an additional $1,600, a 20-50 percent bonus depending on his salary.

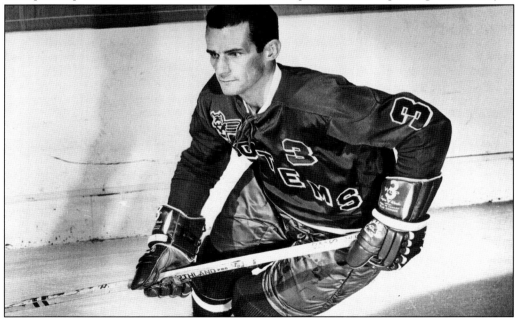

Gordie Sinclair was one of the league's top defensemen during his 16 seasons in the WHL, 11 of which were spent in Seattle (1955–1966). Known as "Wedge" by his teammates (due to his wedge shaped head), Sinclair was a small player even for the era, at 5-foot-10 and around 150 pounds. He was an excellent skater and an offensive threat, averaging 43 points per season from the blueline. He was a seven time all-star while in Seattle and won a championship with the Totems in 1959.

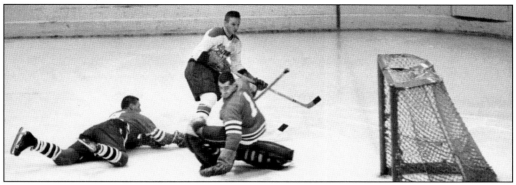

Don Chiupka (in white) shoots wide of the net against the Portland Buckaroos in the early 1960s. Goaltenders during this era did not wear masks, which did not become a common practice until the later part of the decade. The slap shot was still uncommon, and the majority of skaters favored flat stick blades, keeping shots both slower and lower than is seen in the modern era. Still, goalies were in constant danger from pucks, errant sticks, and anything else that could hit them in the head or face. Goal posts were especially dangerous, as the nets were held in place by long steel posts making the goal difficult to dislodge.

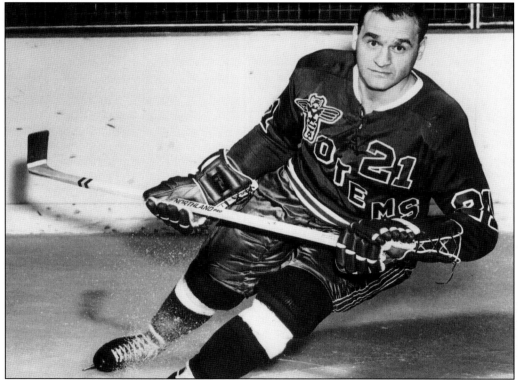

Ray Kinasewich suited up twice in Seattle, first with the Americans from 1956 to 1958 and later with the Totems during the 1964–1965 season (shown here). His 44 goals in 1956–1957 led the WHL and his 86 goals in back-to-back seasons is a record for a professional in Seattle (Bill MacFarland also had 86 goals in two consecutive seasons from 1960 to 1962). Kinasewich played alongside Val Fonteyne and Guyle Fielder while with the Americans and that line led the league in scoring both seasons, combining for a total of 203 goals.

The Totems moved from the cramped confines of the Civic Arena to the spacious Coliseum to start the 1964–1965 season. Whereas the Arena could hold roughly 4,500 fans for hockey, the Coliseum was capable of hosting crowds of over 12,000. Originally constructed for the 1962 World's Fair, the Coliseum remained the home of the Totems until their demise in the spring of 1975. Hockey returned to the building in the late 1980s when the Thunderbirds began playing some games there. It was remodeled in the early 1990s, and starting in the fall of 1995 it became the permanent home of the Thunderbirds. Shown here are Totems defenseman Gordie Sinclair (left) and forward Bill MacFarland (right), who are testing out the first sheet of ice ever laid at the Coliseum along with their sons. (Courtesy of the *Seattle Post–Intelligencer* Collection, Museum of History & Industry.)

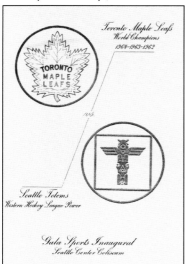

The first sporting event ever held in the Coliseum was an exhibition game between the Totems and the Toronto Maple Leafs on September 30, 1964. Just over 8,600 fans turned out to see the Totems fall to the defending Stanley Cup champs by a score of 7-1. Many of the more loyal fans attended a black-tie dinner and reception following the game (invitation shown here), and even the Toronto coaches Punch Imlach and King Clancy got into the spirit of the evening by donning tuxedos and top hats on the Maple Leafs' bench. (Courtesy of Dave Eskenazi.)

Seattle Totems Hockey Booster Club

1967 Annual Awards Banquet

Moose Lodge March 17, 1967

The Totems had a very active Booster Club throughout the 1960s, peaking at around 400 members. The club was involved planning trips to road games as well as organizing an awards banquet every season (top) for the players and fans. Some of the more ambitious boosters showed their pride in non-hockey related ways, such as sponsoring a racecar driven in events at local tracks (bottom). (Courtesy of Johnnie Jones.)

Keith "Bingo" Allen is the dean of Seattle hockey coaches, spending more seasons behind the bench (9) in the city than anyone else. Allen originally came to the Americans as a defenseman and coach in 1956–1957. He hung up his skates for good following that season and concentrated on his duties as head coach and general manager through the 1964–65 campaign. During his tenure the franchise had a regular season record of 319-270-41, with two first place finishes and only one losing record. He led the Totems to three WHL finals appearances, winning a championship in 1959, and was named the *Hockey News* Minor League Executive of the Year for the 1959–1960 season. Allen had a reputation as being very soft-spoken and treating his players with respect. He stayed on as general manager with the Totems during the 1965–66 season before moving on to the expansion Philadelphia Flyers of the NHL. He served as the Flyers coach from 1967 to 1969, after which he moved into the front office where he still works today. Allen was inducted into the Hockey Hall of Fame in 1992.

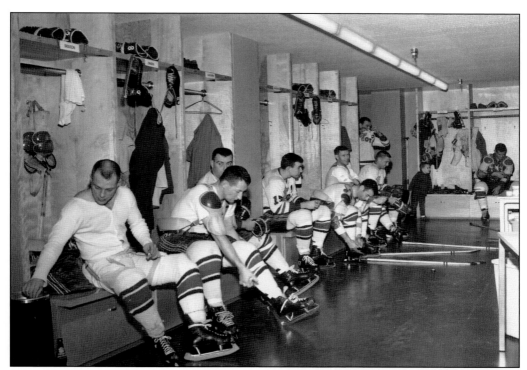

When they're not on the ice, players feel most at home in the locker room, as this photo from the 1964–65 season shows. The players, from left to right, are Gerry Brisson, Bill Dineen, Bob Sabourin, Larry Hale (seated in the stall of Ray Kinasewich), Guyle Fielder, Jim Powers, Bob Barlow, Ray Kinasewich (standing), and Don Ward. (The child is unidentified.) The club finished the season in second but fell to the Victoria Cougars in the opening round of the playoffs, blowing a three-games-to-one series lead by losing the final three contests. (Courtesy of the *Seattle Post–Intelligencer* Collection, Museum of History & Industry.)

Dick Bielous was the trainer of the Americans and Totems for 10 seasons from 1957 to 1967. He was a jack-of-all-trades, ordering supplies, repairing and cleaning all of the uniforms and gear, and packing and unpacking all of the equipment. Bielous also provided physical therapy and emergency repairs to players who were injured over the course of the season. During the off-season he worked as a minor league baseball trainer with the Edmonton Eskimos and Vancouver Mounties.

High expectations were placed upon coach Bobby Kromm when he took over the reins of the Totems for the 1965–1966 season. He came to Seattle with an impressive hockey resume that included playing on and coaching the 1961 World Champion Trail Smoke Eaters, as well as coaching the Nelson Maple Leafs to the 1965 Allan Cup finals. Kromm was known to be a strict coach, and his style didn't fit well with the veteran Totems who staggered to a disappointing 32-37-3 record. They finished in fifth place and out of the playoffs, the first time since 1956 the team had failed to make it to the postseason. Kromm did not return the following year.

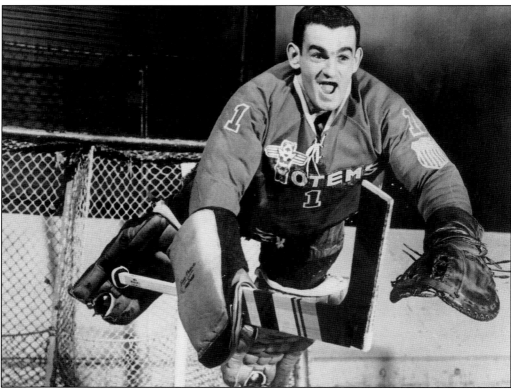

Jim McLeod opened the 1960-61 season as the starting goaltender for the Totems due to a training camp eye injury to veteran Bev Bentley. Once Bentley was healthy enough to return to action, McLeod was relegated to the bench. The following season he was slated as the team's starter, but was replaced early in the season by Al Millar. After moving to California for a few seasons, McLeod returned to Seattle as the starter for the Totems from 1964-67. He earned the WHL Outstanding Goaltender Award in 1965 and 1967, leading the club to the league championship in 1967. That summer, in a surprise move, the Totems and Portland Buckaroos traded goalies, with McLeod going to Portland and Don Head coming to Seattle. The deal paid off for the Totems, who went on to win their second consecutive championship in 1968 with Head in net.

Jim Armstrong spent three seasons in net for the Totems from 1966 to 1969, playing a surprising number of games as a backup. He acted as an insurance policy for Seattle's veteran goaltenders during the late 1960s, allowing them to take time off and stay healthy. Armstrong's career almost came to a tragic end on March 29, 1969, when he went down trying to make a save on a breakaway by Randy Miller of the Denver Spurs. He hit is neck on the goalpost and lay paralyzed on the ice. After an evening in the hospital, the sensation in his extremities began to return and he eventually made a full recovery, playing four more seasons as a professional before retiring from the game in 1974.

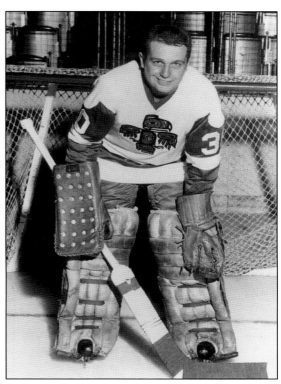

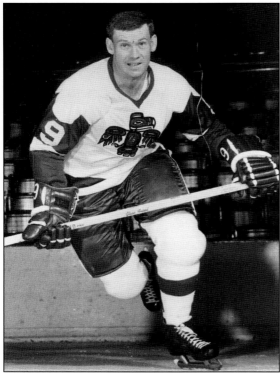

"Jumbo" Jim Powers was acquired in a trade for Alex Kuzma early in the 1958–1959 season, his first of nine with the Totems. The big left wing teamed up with Guyle Fielder and Bob Barlow to comprise the top scoring line in the WHL for two straight seasons from 1962 to 1964, averaging 31 goals per year. Powers played on the 1959 and 1967 championship squads and remained in the Seattle after retiring from hockey, operating a very successful motorcycle dealership.

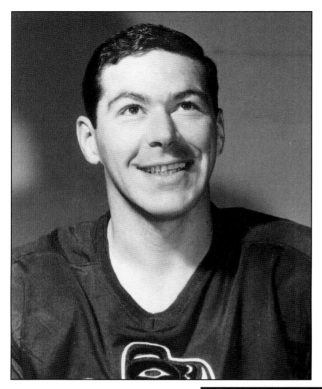

Noel Picard, the big (6'1", 210 lbs) French-Canadian defenseman, spent only one season in Seattle but made his presence felt. He was part of a defensive corps referred to as the "Jolly Green Giants" due to their large size and physical play. Picard was second on the team in penalty minutes (135) during the 1966–1967 season, and in one celebrated incident punched out Barry Van Gerbig, owner of the San Francisco Seals, during an altercation between periods. In the 1967 WHL finals Picard showed another side of his game, scoring or assisting on the game-winning goal in three of the four games as the Totems swept the Vancouver Canucks to earn their first championship since 1959.

By the time Bill Dineen arrived in Seattle for the start of the 1964–1965 season the 32-year old winger was already a veteran of five NHL seasons with Detroit and Chicago, as well as six more in the AHL. He spent the next six seasons in Seattle, averaging 21 goals per year and contributing to the Totems back-to-back championships of 1966 and 1967. Dineen suffered a bizarre shoulder injury in March of 1967 when he was involved in an altercation with an assailant in his driveway following a home game. He was the team's leading scorer at the time and missed eight games. Fortunately he was healthy for the playoffs, scoring nine points in ten games as the Totems won their third WHL title.

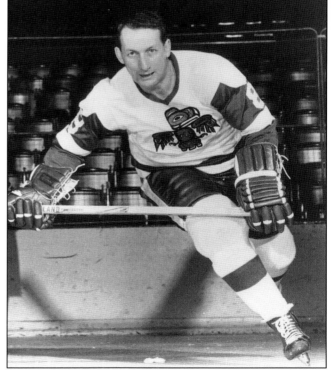

Earl Heiskala led the Totems in penalty minutes for three consecutive seasons from 1965 to 1968, leading the entire WHL in 1967–1968 with 157 PIM and five major penalties. While known primarily for his physical play, Heiskala was also a skilled forward and his 26 goals in 1967–1968 were second best on the team. Though he had a reputation as a tough guy, Earl was very matter-of-fact about the role of fighting: "I don't believe in picking fights. I don't think fighting is that important in hockey as long as they know you will fight and can fight." Following his four seasons in Seattle Heiskala made it to the NHL with Philadelphia, appearing in 127 games over three seasons.

Chuck Holmes was well acquainted with Seattle fans prior to joining the Totems in 1964–1965. He had played against Seattle for eight seasons while with Edmonton, incurring the wrath of the local fans when he was involved in an unfortunate altercation with a spectator that left a woman sitting nearby injured by his stick. All was forgiven when he joined the Totems, and he became a fan favorite during his six seasons with the team. Holmes retired as a player after the 1970–1971 season, only to step behind the bench the following year to coach the worst team in WHL history, the 1971–1972 Totems.

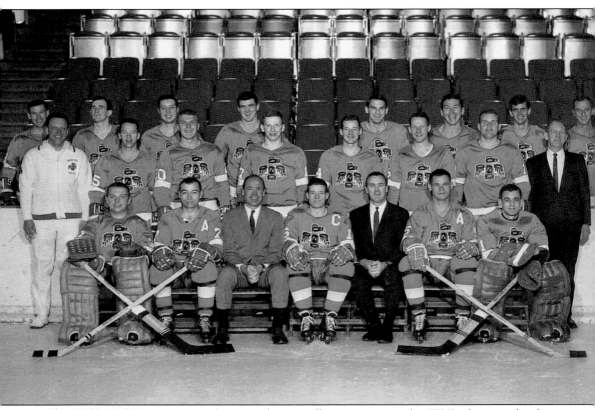

The 1966–1967 Totems were the second worst offensive team in the WHL; fortunately, they were the best defensive team in the league, allowing only 195 goals against. They finished the season in second with a 39-26-7 record by relying on their defensive corps. Known as the "Jolly Green Giants," they led the league with 923 penalty minutes and 19 major penalties. The season started tough for rookie coach Bill MacFarland, and the Totems didn't make it over .500 to stay until the end of January. The tide began to turn with the acquisition of tough defenseman Pat Quinn and the return of veteran blueliner Don Ward, who had been out of the lineup following knee surgery. An 11-game unbeaten streak (a franchise record) in March gave the team confidence, and a massive 20-minute bench-clearing brawl with Portland in the second to last game of the season sent a message to the rest of the league. Guyle Fielder earned his last scoring title and his final MVP award, and goaltenders Jim Armstrong and Jim McLeod shared the Outstanding Goalkeeper honors. In the playoffs the Totems bumped off the California Seals in the first round and swept Vancouver in the finals. It was the Totems' first championship since 1959, and the club was now 8-0 in two trips to the finals games. Walt Parietti of the *Seattle Times* summed up the team best: "They notably lack finesse, substituting muscle instead. Sharp puck handling in their own zone and hustle on defense are the team's outstanding attributes." As a result of the second place regular season finish and the championship, each player received $1,525 in bonus money. The 1966–1967 Totems are pictured, from left to right, as follows: (front row) Jim Armstrong, Guyle Fielder, Bill MacFarland (coach), Gerry Leonard, Murray Costello (executive), Don Ward, and Jim McLeod; (middle row) Dick Bielous (trainer), Howie Hughes, Jim Paterson, Don Fedun, Les Hunt, Bill Dineen, Earl Heiskala, and Bill Sheppard; (back row) Jim Powers, Don Chiz, Jean Gauthier, Pat Quinn, Bob Lemieux, Noel Picard, Larry Lund, and Chuck Holmes.

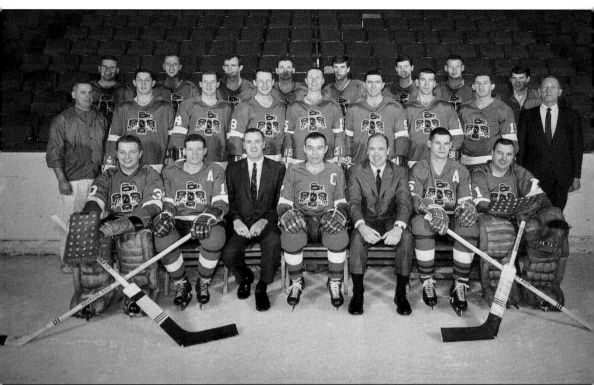

The 1967–1968 regular season was almost a repeat of the previous year for the Totems. The club again finished in second place (35-30-7), though the offensive fell off to become the lowest scoring in the WHL. They again relied on their defense, which was the second best (199 goals against) and most penalized (948 PIM) in the league. There was a surprising amount of turnover on the roster, with seven players from the 1966–1967 championship squad leaving the club, including starting goaltender Jim McLeod who was traded to Portland for Buckaroos starter Don Head. Unlike the previous season, the Totems came out of the gate hot, going undefeated in their first 10 games (8-0-2). Unfortunately they managed only 11 wins over the next 31 games, falling back to around .500. Tensions were building, and even coach Bill MacFarland was feeling the pressure, as was evidenced by his ejection from a game on January 5 for calling referee Lloyd Gilmour a "homer" and throwing a towel at him. The Totems continued to survive on the strength of their defense and physical play, and for the second straight year ended the season in a fracas with the Buckaroos, which ended with two players penalized for making contact with on-ice officials and a fan throwing a coffee can at Connie Madigan. After sweeping Phoenix in the first round of the playoffs the Totems met Portland in the finals, winning that series four games to one to win their second consecutive WHL championship. The 1967–1968 Totems included, from left to right, the following: (front row) Jim Armstrong, Gerry Leonard, Murray Costello (executive), Guyle Fielder, Bill MacFarland (coach), Don Ward, and Don Head; (middle row) Pat Dunn (trainer), Dwight Carruthers, Don Chiz, Bill Dineen, Cleland Mortson, Marc Boileau, Bob Courcy, Tom Iannone, and Bill Sheppard; (back row) Earl Heiskala, Chuck Holmes, Larry Hale, Paul Cates, Larry Lund, Gary Kilpatrick, Ray Larose, and Steve Schonely.

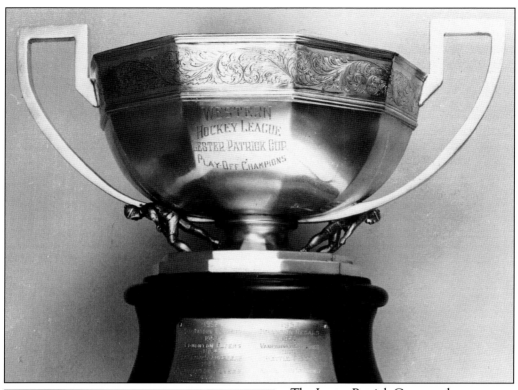

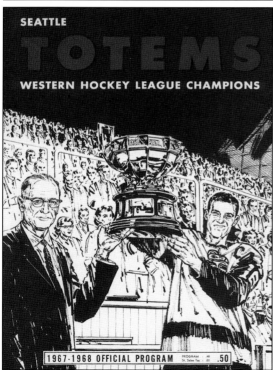

The Lester Patrick Cup was the championship trophy of the Western Hockey League. The Seattle Totems won the trophy three times: 1959, 1966 and 1967. The league record for most championships by a single club was four, held by the Vancouver Canucks.

The greatest come-from-behind win in Seattle hockey history took place on April 20, 1968, the second game of the WHL finals against the Portland Buckaroos. The Totems, playing at home in the Coliseum, trailed 6-2 after two periods of play. Two quick goals in the first 1:16 of the third period cut the lead in half, and Bob Courcy got Seattle to within one with just under nine minutes remaining. MacFarland pulled his goaltender for the extra attacker late in the game, and the move paid off as Chuck Holmes tied it with 19 seconds left. Guyle Fielder got the game winner at 6:19 of overtime to give the Totems a 7-6 win and a two games to none advantage in the series.

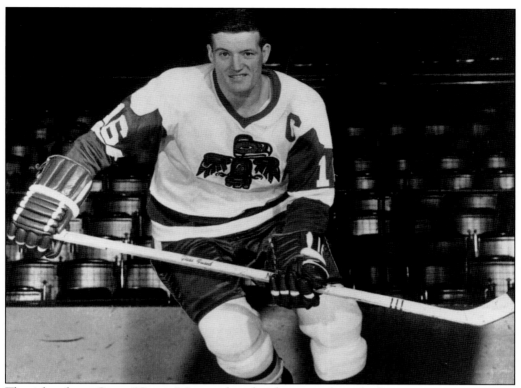

The joke about Gerry "Grump" Leonard is that he went through the entire season uttering only two words: "Hello" at the start of training camp and "Goodbye" when the season ended. In between he was one of the most accomplished checkers in the WHL, a versatile player who spent most of his time on the third line but could capably fill in with the big guns and contribute offensively when needed. Leonard played 12 consecutive seasons with the Totems from 1958 to 1970, good for third all-time in regular season games played in Seattle with 842. He is one of two Totems to play on all three championship teams, the other being fellow center Guyle Fielder.

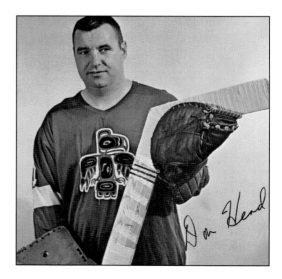

During the summer of 1967 the Totems raised a lot of eyebrows by trading starting goaltender Jim McLeod, who won the Outstanding Goaltender award and helped the team to the WHL championship that spring, to the Portland Buckaroos for Don Head. Head was four years older than McLeod, and injuries were starting to take their toll. It turned out to be a great trade as the Totems won their second consecutive championship in 1968 with Head in net. He played two full seasons in Seattle before an injury during the 1969–1970 home opener left him with three cracked ribs. Head played in only 34 games over two seasons following the injury, retiring in 1972.

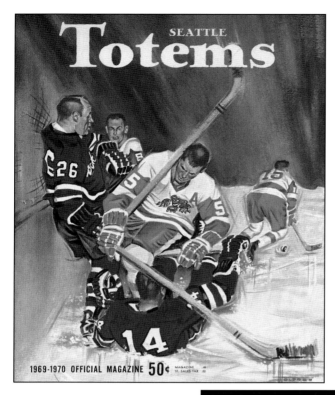

SEATTLE
Totems

1969-1970 OFFICIAL MAGAZINE 50¢ MAGAZINE .48 ST. SALES TAX .02

The 1969–1970 season began the decline of the Totems franchise. For the second straight season the club finished in fourth, though this time their record dropped below .500. Seattle and Phoenix finished the regular season tied with 66 points, forcing a one-game playoff to determine which team would advance to the postseason. The Totems won the game 3-1, but lost their first round playoff series to Portland four games to two. It was the last playoff appearance for the Totems, and 1969–1970 was the first of six consecutive losing seasons.

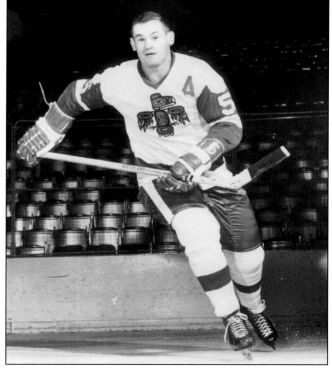

Big Don Ward (6'2", 200 lbs) was a mainstay on the Seattle blueline for 11 seasons from 1961 to 1972. He was a physical presence on defense, and his 1,110 penalty minutes are the most ever by any player in a Seattle uniform. Injuries cost Ward a significant number of games, and in five of his seasons with the Totems he missed 14 or more games with various ailments, many related to his knees. His son, Joe Ward, played three seasons with the Seattle Breakers from 1978 to 1981.

Jack Michie was a 21-year-old rookie when he arrived in Seattle for the 1968–1969 season, spending much of the year on a line with Guyle Fielder and Bob Courcy. He played all 74 games that season, picking up 19 goals and 47 points and winning WHL Rookie of the Year honors. The Totems nearly made a clean sweep of the league awards that season, with Michie as ROY, defenseman John Hanna winning the Laycoe Cup (top defenseman) and the league MVP award, and Guyle Fielder earning the Hume Cup as the league's most gentlemanly player. Michie played four full seasons with the Totems before joining the Tulsa Oilers early in the 1972–1973 campaign.

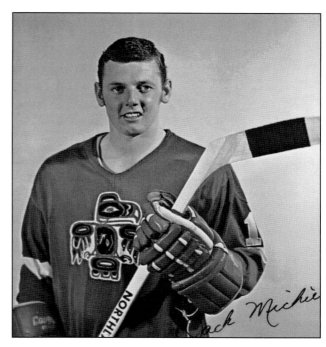

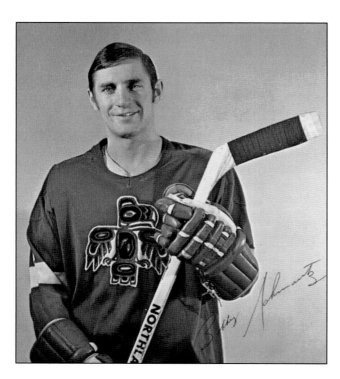

Guyle Fielder came out of retirement at the start of the 1969–1970 season to play for Ray Kinasewich, his former linemate, in Salt Lake City. In order to acquire Fielder, the expansion Gulls traded forward Bobby Schmautz to Seattle. His 27 goals were third best on the team, even though he only appeared in 54 games with the Totems that season. He is perhaps best remembered by Seattle fans for engaging in stick fight with Jim Murray of the Phoenix Roadrunners, costing him a $100 fine and a one game suspension. Bobby's rights were sold to Vancouver of the NHL during the following season, and he remained in the NHL for the balance of his career.

Howie Hughes played four seasons with the Totems, but interestingly he never played back-to-back seasons in Seattle. Hughes first appeared in a Seattle uniform in 1961–1962, but did not return to the city again until 1966–1967, when he scored 26 goals and 71 points for the league champions. Following that season he spent three years in the NHL with the Los Angeles Kings before returning to the minors. He re-surfaced in Seattle for the abysmal 1971–1972 season and then departed again, making his last appearance in 1974–1975, his final season in hockey.

The 1971–1972 Totems were unquestionably the worst hockey team ever to play in Seattle. After stumbling out of the gate with a 2-7-0 record to start the season, the club embarked on an 18-game losing streak to drop to 2-25-0. The season also included winless streaks of 11 and 12 games, as well as a 32-game road losing streak. The Totems finished the year with an all-time league worst 12-53-7 record, and their 175 goals scored was the lowest total in league history. Don Westbrooke led the team in goals with 23 while Jim Peters led in total scoring with a paltry 52 points.

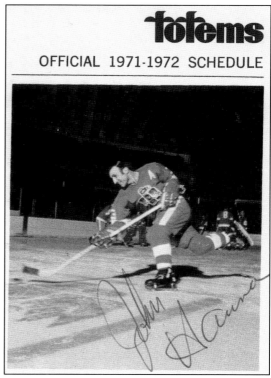

totems

OFFICIAL 1971-1972 SCHEDULE

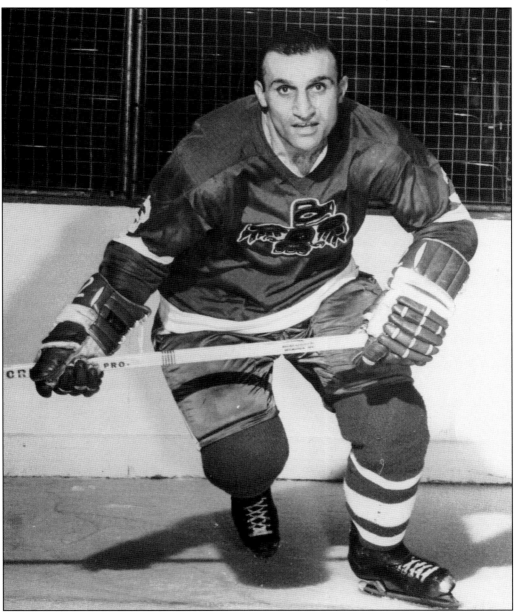

Born in Nova Scotia and of Lebanese descent, John Hanna didn't learn to skate until he was 13 years old. All that lost time didn't stop him from becoming an excellent defenseman, and by time he arrived in Seattle for the 1968–1969 campaign he was already a veteran of 11 seasons in the AHL and NHL. He was known primarily for his mobility and stick-handling, though not as a goal scoring threat. That all changed his first year with the Totems when Hanna exploded, netting 25 goals and earning the Laycoe Cup as the WHL's top defenseman and the league MVP award. Two seasons later, in 1970–1971, his 60 points (20 goals, 40 assists) tied for the team lead in scoring and earned him his second Laycoe Cup. He missed much of the catastrophic 1971–1972 season while recovering from hernia surgery. Hanna was one of the team's top stars during the early 1970s.

13A 63 F 5
AISLE SEC. ROW SEAT
BALCONY
ESTAB. PRICE $3.81 + CITY TAX .19
TOTAL $4.00
INTERNATIONAL
HOCKEY EXHIBITION

USA

seattle totems
vs.
U. S. S. R.
NATIONAL CHAMPIONS
SEATTLE CENTER COLISEUM
MONDAY, DECEMBER 25, 1972
TIME 7:30 P.M.

Now the president of the WHL, former Totem Bill MacFarland arranged for a series of exhibition games between WHL clubs and the national team from Russia during the winter of 1972–1973. The Russians, fresh off of their near upset of Canada during the Summit Series three months prior, were in the United States preparing for the World Cup tournament in Minnesota. The Russian team, which included 17 players who skated against Canada, looked upon the exhibitions not only as a warm-up for the tournament, but also a means to earn some hard currency to offset the costs of their trip (a very capitalist idea).

On December 25, 1972, the Totems faced the Russian national team in an exhibition game in Seattle. Over 12,000 fans packed the Coliseum and watched the Soviets jump out to a 3-0 first period lead. The Totems narrowed the gap, and by the end of the second they had cut the margin to one goal, trailing 5-4. The Russians turned it up a notch in the third, scoring four times and winning the game by a final of 9-4. The entire exhibition series was a rousing success, with players and fans alike praising the skill of the Russians, winners of all four of their games against WHL opponents.

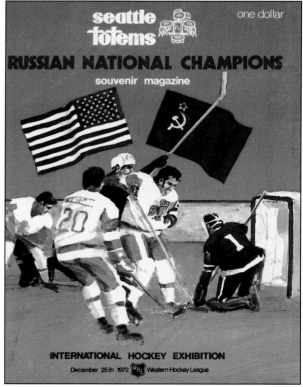

seattle totems one dollar
RUSSIAN NATIONAL CHAMPIONS
souvenir magazine

INTERNATIONAL HOCKEY EXHIBITION
December 25th 1972 WHL Western Hockey League

96

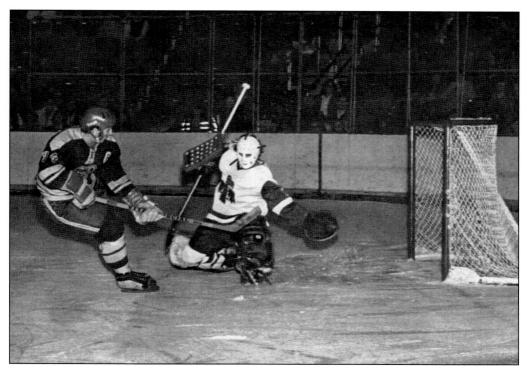

After the fantastic success of the exhibition series with the Soviets in 1972–1973, a similar exhibition tour was arranged the following winter which included both Russia and Czechoslovakia. The Czechs started their tour first and played in Seattle on December 25, 1973, in front of just over 6,000 fans at the Coliseum. The Totems broke a 3-3 tie in the third with two goals, but the Czechs got one of their own to cut the lead to 5-4 late in the game. Czech captain Jan Hrbaty got a breakaway with just over a minute to play, but was stopped by Totems netminder Bruce Bullock (shown here) to preserve the win for Seattle. The Totems scored on the empty net in the final minute to come away with a 6-4 win.

The Totems faced-off against the Russians for a second time on January 5, 1974. It was the final exhibition game for the Russians, who were undefeated after beating Phoenix, Portland and San Diego. A crowd of 12,700 was on hand to see the Totems score four goals against goaltender Vladislav Tretiak in the second period to take a 5-2 lead. During the second intermission the Russians suited up a number of players who had been scratched from the line-up, but the fresh legs didn't help and the Totems won by a score of 8-4. It was the only win by a WHL club over the Russians in eight attempts.

AISLE 23

15 M 8
SEC. ROW SEAT
MAIN FLOOR

EST. PR. $5.71 + CITY TAX .29
TOTAL $6.00

INTERNATIONAL
HOCKEY
EXHIBITION

seattle
Totems

VS.
RUSSIA
SEATTLE CENTER COLISEUM
SAT. EVE. 7:30 P.M.
JANUARY 5, 1974

Don Westbrooke played three seasons with the Totems from 1971 to 1974. The right winger averaged 27 goals per season in Seattle, and is perhaps best remembered for his performance against Russia in 1974 when he scored three goals and an assist against arguably the best team in the world.

Rob Walton only played one season in Seattle, but he made it count. His 61 assists and 101 points in 1972–1973 led the league, and he became the only Seattle player besides Guyle Fielder to score 100 or more points in a season as a professional. In fact, he and Fielder are the only two players to break that mark in a Seattle uniform from 1915 to 1975.

Six

Guyle Fielder

In the eyes of many fans, being referred to as the greatest minor leaguer of all time would seem to be a dubious distinction. Most assume that if a player had a long career in the minors it means that he wasn't good enough to play in the NHL. While there is some truth to that line of thinking, particularly in the 30-team NHL of today, it wasn't always the case. Prior to the first expansion in 1967, the NHL consisted of only six teams and roster sizes were smaller than today. It was much more difficult to crack the lineup of an NHL club, and many excellent players spent the majority of their careers in the minors. It was during this era that many of the best minor leaguers of all time played, and the greatest of them all was Guyle Fielder.

Born in Potlach, Idaho in 1930, Fielder was raised in Nipawin, Saskatchewan. He played junior hockey with the Lethbridge Native Sons, leading the WCJHL in scoring during both seasons there. In 1945, at the age of fifteen, Fielder signed his first professional contract with the Chicago Black Hawks for a $100 signing bonus. He made his pro debut with them at the tail end of the 1950–1951 season, appearing in three games and being kept off the scoring sheet.

His first full season of pro hockey was with the New Westminster Royals of the PCHL in 1951–1952, and his 25 goals and 75 points earned him the league's Rookie of the Year award. He was assigned to the St. Louis Flyers of the AHL the following season, and for the second straight year received Rookie of the Year honors. He also got his second shot at the NHL, suiting up for four games during the 1952 playoffs with the Detroit Red Wings, who had acquired his rights.

Fielder was farmed out to the Seattle Bombers for the 1953–1954 season, his first in the city where he would go on to have his greatest success. He played 15 seasons in Seattle from 1953 to 1969 with the Bombers, Americans and Totems, setting the franchise regular season records for games played (1,036), goals (323), assists (1,099) and total points (1,422). (He played with New Westminster during the 1954–1955 season when the Seattle franchise dropped out of the league.) Along the way he earned six MVP awards, led the WHL in assists 13 times, and led the league in scoring nine times.

A small player at 5-foot-9 and 160 pounds, Fielder was known throughout the hockey world for his passing skills, and a number of players had career years when skating alongside him. Ray Kinasewich put together back-to-back 40-plus-goal seasons with the Americans on Fielder's line, the only time in his career that he ever scored more than 31 goals in season. Wayne Brown's 49 goals in 1953–1954 while skating with Fielder were 19 more than he scored in any other season. Because his assist statistics are so impressive, his goal-scoring prowess is often overlooked. While he never led the league in goals, during his time in Seattle Fielder averaged 21 goals per season.

The Red Wings brought him to training camp in the fall of 1957, and Fielder got his last shot at the NHL. He opened the 1957–1958 season in Detroit, but received limited ice time during the first six games of the season. More than anything Fielder wanted to play, not watch, and he asked Detroit general manager Jack Adams to send him back to Seattle. The Americans welcomed him back with open arms, and despite missing the first eight games of the season he led the WHL with 111 points and earned his second MVP award. His NHL career was finished after 15 games, spread out over four seasons with three different teams (Chicago, Boston and Detroit). The all-time minor league scoring leader didn't score a single point in the NHL.

Back in Seattle, Fielder led the Totems to three WHL championships and five trips to the league finals. He retired briefly following the 1968–1969 season but returned to play for former teammate Ray Kinasewich, the coach of the WHL expansion franchise in Salt Lake City. He remained with the Eagles until January of 1972 when he was traded to the Portland Buckaroos, where he remained until he retired for good following the 1972-73 season.

There has always been a lingering question about Fielder's career—why did a player with so much talent not get a chance to prove himself in the NHL? Part of the answer lies in the limited number of jobs available in the NHL during Fielder's most productive years. Also, in the era before free agency, the only way for a team to acquire the rights to a player was through a trade or cash purchase, and other clubs may have been scared away by the asking price. It wasn't uncommon for a quality player to languish in the minors simply because it allowed the club holding his rights to prevent the competition from getting better. There is also a question of motivation on Fielder's part. After all, he made a good living in the WHL and was one of the league's top stars. There wasn't necessarily a lot of incentive for him to move to the NHL where he would be forced to re-establish himself and possibly even take a pay cut. There isn't one answer to the question, it's likely more a combination of various factors that when taken together resulted in Fielder having a long and distinguished career in the WHL.

Over the course of 22 seasons as a pro Fielder scored 2,037 points, all of them in the minors. He is the player most identified with hockey in Seattle and his time in the city coincided with the greatest era of success for the sport, both on the ice and in terms of attendance. To this day he is still remembered fondly by local hockey fans, skating down the ice with number "7" on his back, making a no look pass to a streaking winger for a goal. He is now and likely will always be the greatest player in the history of hockey in Seattle.

After wrapping up his final season of junior hockey with the Lethbridge Native Sons, Fielder was called up to the Chicago Black Hawks of the NHL for two games in the spring of 1951, failing to register a point. The following season, he was assigned to the New Westminster Royals of the PCHL (shown here). In his first full season as a professional with the Royals he scored 25 goals and 75 points to lead all rookies in scoring and earning the league's Rookie of the Year award.

Assigned to the St. Louis Flyers of the AHL for the 1952–1953 season, Fielder (top row, second from the right, wearing No.15) earned his second consecutive Rookie of the Year award and was named a second team all-star. His 22 goals and 83 points led the Flyers in scoring. After the AHL season ended Fielder was again called up to the NHL, this time to join the Detroit Red Wings in the playoffs. He appeared in four games but failed to score.

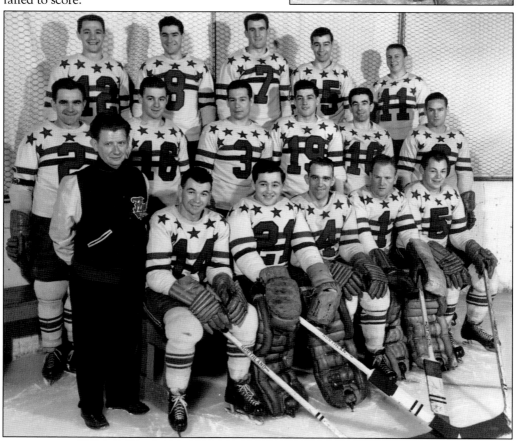

When the Seattle Bombers missed the post-season in 1953–1954, Guyle got his third opportunity in the NHL when he was called up by the Boston Bruins for the 1954 playoffs. Though he led the WHL in assists and scoring during the season, he saw little action in his two games with Boston. It was in one of these games that Fielder earned his only NHL "statistic," taking a two-minute minor penalty.

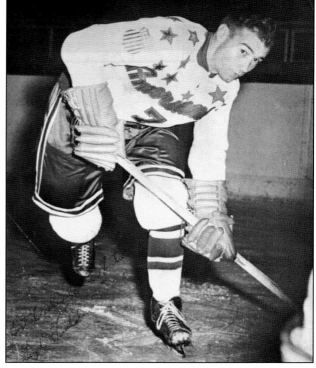

Hockey returned to Seattle after a one-year hiatus in the fall of 1955 when television executive Bill Veneman purchased the defunct Bombers, renaming them the Americans. Fielder, who led the Bombers and the WHL in scoring in 1953–1954, returned to Seattle to join the Americans for the 1955–1956 season. Once again he led the team in scoring, this time with 18 goals and 79 points. Among the new arrivals in Seattle that year were Val Fonteyne and Gordie Sinclair, who along with Fielder were integral parts of the rebuilding process over the next four seasons.

By his third season in Seattle, Fielder was such an important part of the franchise that the Americans put him on the cover of their programs for the entire season. He repaid the honor with the greatest scoring season ever by a professional hockey player at that time, setting records in assists (89) and points (122) and winning his first of four consecutive league MVP awards. Led by Fielder, the Americans finished atop the standings in the WHL Coast Division with a 36-28-6 record. They had the most potent offense in the league, scoring 263 goals over the course of 70 games. What made the season even more impressive was that the previous year the Americans finished in the cellar, six games below .500.

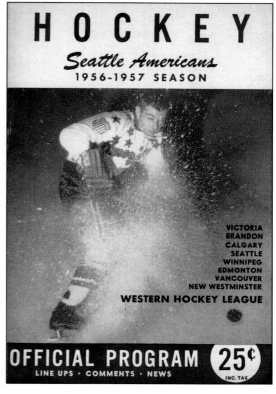

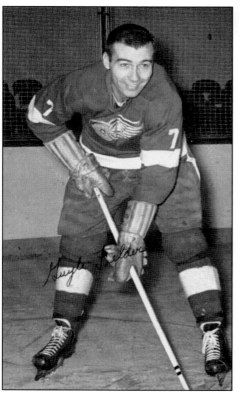

Guyle's last chance in the NHL came in the fall of 1957 with the Detroit Red Wings. He made the roster out of training camp and started the season in Detroit. After seeing limited ice time with the Red Wings as they opened the season with six consecutive losses, he told GM Jack Adams that he would rather play in the WHL than sit on the bench in Detroit. He was returned to Seattle where he scored 111 points despite missing the first eight games, earning his second consecutive league MVP award. The stint in Detroit was Fielder's last appearance in the NHL. He played in 15 NHL games (six in the playoffs) and did not score a point.

103

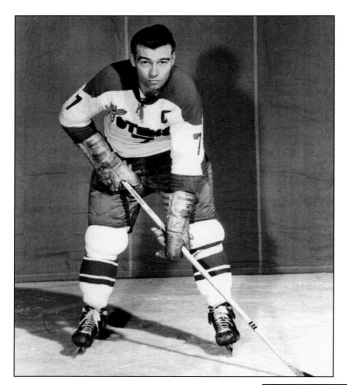

While the team's name changed prior to the start of the 1958–1959 season, Fielder's play didn't and once again he was again stellar. He led the league in both assists (95) and points (119) for the third consecutive season, winning his third straight MVP award. He added another 13 points in the playoffs as the Totems easily rolled to their first of three WHL championships.

Owner Bill Veneman sold the Americans in the summer of 1958 to a new ownership group consisting of twelve local hockey enthusiasts. The new owners changed the club's name to the Totems for the 1958–1959 season. They were the top offensive club in the WHL that year, with seven players scoring 24 goals or more. The Totems finished atop the division with a 40-27-3 record and went 11-1 in the playoffs, winning their first ever WHL championship.

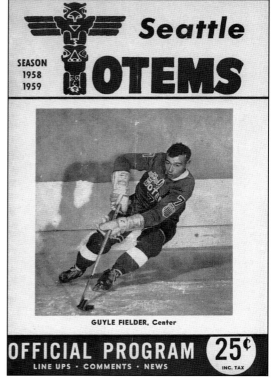

SEASON 1958 1959

Seattle TOTEMS

GUYLE FIELDER, Center

OFFICIAL PROGRAM 25¢
LINE UPS · COMMENTS · NEWS
INC. TAX

Fielder was at the pinnacle of his career during the 1959–1960 season. In addition to leading the WHL in assists and total points for the fourth consecutive season, he was also named to his fourth straight all-star team and was named the league MVP for a record fourth consecutive time. He is shown here with the Hiram Walker Award, presented annually to the WHL MVP. (Courtesy of the *Seattle Post–Intelligencer* Collection, Museum of History and Industry.)

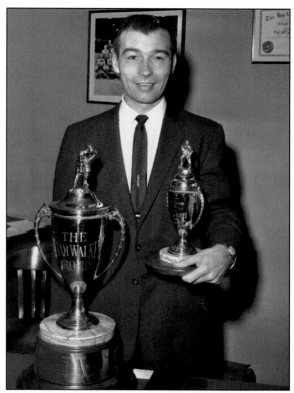

Known primarily for his skating and passing skills, Fielder was also a goal-scoring threat. While he never led the league in that department, he averaged 21 goals per season with Seattle. He is shown here looking for an opening against goalie Marcel Pelletier of the Los Angeles Blades during the 1961–1962 season. Note the "signature" tape job on the blade of his stick, with tape at both ends and an exposed blade in the middle.

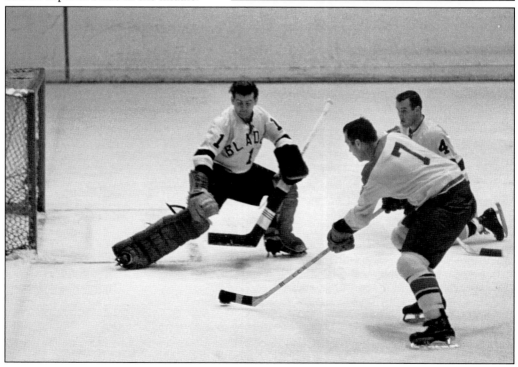

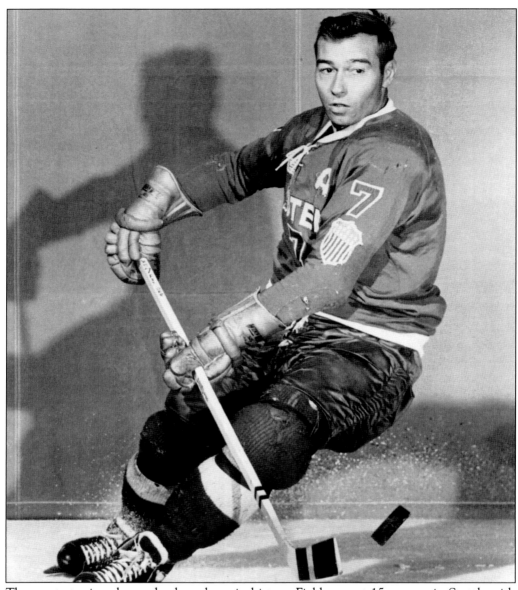

The greatest minor league hockey player in history, Fielder spent 15 seasons in Seattle with the Bombers, Americans, and Totems. During that time his teams played in the WHL finals five times, winning three championships. The all-time minor league scoring leader, Fielder led the WHL in assists during 13 of his 15 seasons in Seattle, also pacing the league in total points nine times. A 12-time all-star, he set a league record by earning six MVP awards. He hung up his skates following the 1968–1969 season but was coaxed out of retirement to play for former linemate Ray Kinasewich, the new coach in Salt Lake City. After a pair of solid seasons with the Eagles, he was traded to the Portland Buckaroos where he finished his 23-year professional career following the 1972–1973 season at the age of 42. Despite his success in the minors, Fielder appeared in only 15 NHL games, never scoring a point. The *Hockey News'* 50th Anniversary Special issue named him the best player in the history of the Western Hockey League.

On April 2, 1961 Seattle hosted "Guyle Fielder Night" at the Civic Arena. A sold-out crowd watched Fielder score three points (one goal, two assists) to lead the Totems to an 8-5 win over the Victoria Cougars. Shown here with his wife Beverly, Fielder was presented with gifts by the Seattle fans and the other teams in the league in recognition of his accomplishments, including an all expenses paid trip to Hawaii. During the ceremony he was asked to name his all-time, all-opponent team. He selected Gordy Fashoway, Phil Maloney, and Bill Mosienko as forwards, with Lloyd Durham and Bob Bergeron on defense and Gump Worsley in goal. (Courtesy of the *Seattle Post–Intelligencer* Collection, Museum of History and Industry.)

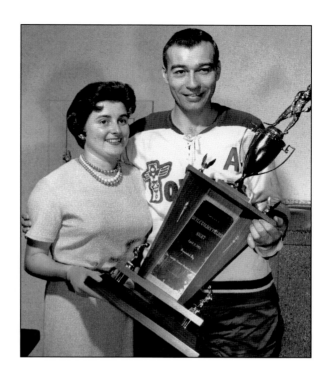

SEATTLE TOTEMS

BOOSTER CLUB

ANNUAL

AWARDS BANQUET

TUESDAY

APRIL 5 1966

6:30 P.M.

Seattle Moose Lodge No. 211

222 Mercer St.

EVERYONE WELCOME

Tickets on Sale at
* BOOSTERS CLUB DESK *
* ALL HOCKEY GAMES *
OR CALL, MARGARET FINNESTAD, EM3-9414

In addition to his skill on the ice, Fielder also had a reputation as a gentleman away from the rink. Always a fan favorite, he was especially popular with the Seattle Totems Booster Club, which at its peak had around 400 members. He was a consistent award winner at the annual Booster Club Award Banquet honoring the best and most popular players on the club. (Courtesy of Dave Eskenazi.)

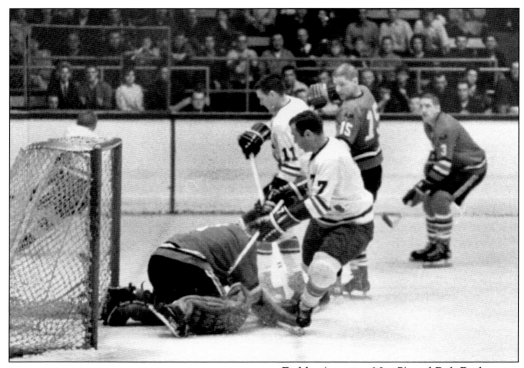

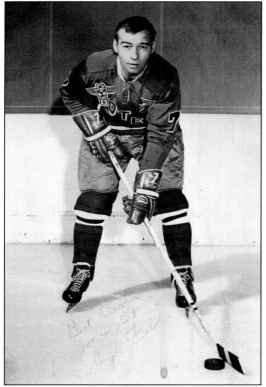

Fielder (wearing No. 7) and Bob Barlow (No. 11) played three seasons together in Seattle from 1962 to 1965. Barlow had outstanding offensive numbers during that period, and his 47 goals in 1962–1963 on Fielder's wing led the league. The line of Fielder, Barlow and Jim Powers was the most potent offensive combination in the WHL from 1962 to 1964, averaging 89 goals per season.

The Totems changed uniform styles for the 1963–1964 season, but Fielder's play remained consistent and again he led the WHL in assists (85) and total points (102). Unfortunately the team didn't do as well, suffering their first losing season (29-35-6) in eight years and finishing out of the playoffs despite having the second best offense and the second best defense in the league. Since the Totems season ended early, Fielder accepted an offer to play with the Quebec Aces in the AHL playoffs, though he was only able to get into one game.

The mid-1960s were productive years for Guyle. He led the league in assists for six consecutive seasons from 1962 to 1968, while also leading the league in total points four times. He was twice named league MVP during that span and was a league all-star in all six seasons. His consistent performance coincided with one of the most successful periods in team history as the Totems made three trips to the league finals, winning the WHL championship twice.

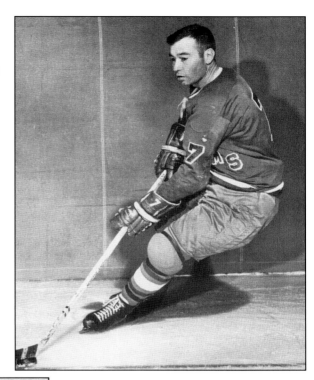

The 1964-65 season was Fielder's last under coach Keith Allen. While the team finished the season in second, they were eliminated in the first round of the playoffs by the Victoria Cougars. Fielder had his greatest success under the soft-spoken coach, leading the WHL in assists eight times, total points seven times, and winning five MVP awards during Allen's tenure.

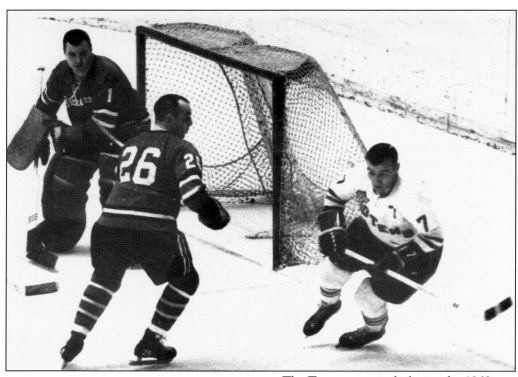

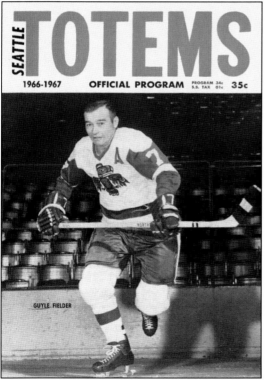

The Totems top rivals during the 1960s were the Portland Buckaroos, led by tough guy Connie Madigan (wearing No. 26). Fielder and Madigan faced each other during seven seasons of the rivalry from 1960 to 1968. Though the Buckaroos finished ahead of Seattle in the standings all seven seasons, the Totems still managed two WHL championships. The clubs met in the WHL finals twice, with the Buckaroos winning in 1961 and the Totems taking the title in 1967. (Photo by Harry Conrad.)

Former Totem Bill MacFarland took over the helm for the 1966–1967 season, and the team responded by winning the WHL championship. For Fielder it was his last season as the league's top player, winning his last scoring title and his final MVP award. He went on to lead the WHL in assists in 1967–1968, the last time he led the league in any category.

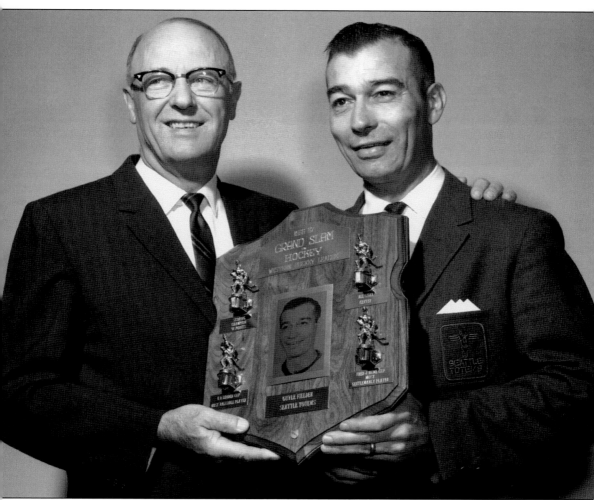

Following the 1966-67 season Fielder (right) was presented with a plaque by league president (and also his uncle) Al Leader (left) for achieving the "Grand Slam in Hockey"—leading the WHL in scoring (91 points), being named a first team all-star, winning the Fred J. Hume Cup as the league's most gentlemanly player, and winning the WHL MVP award. It was the only season in league history that a player received all four honors, and Fielder capped off the season by leading the Totems to their first of two consecutive WHL championships. Fielder was no stranger to awards over the course of his 22 year professional career, putting together an impressive resume: two Rookie of the Year awards, league leader in assists 13 times, WHL scoring leader nine times, 13-time all-star, three Most Gentlemanly Player awards, and six Most Valuable Player Awards. (Courtesy of the *Seattle Post–Intelligencer* Collection, Museum of History and Industry.)

Fielder came out of retirement in 1969–1970 to play under former teammate Ray Kinasewich, who was coaching in Salt Lake City. After two seasons there, he and John Rathwell were traded to the Portland Buckaroos for Fred Hilts and Lyle Brady in January of 1972. Even though he was now in his early 40s, Fielder still averaged almost a point per game (107 points in 110 games) during his season and a half with the Buckaroos, leading the club in assists during the 1972 playoffs with 10 helpers in 11 games.

In addition to being a great hockey player, Fielder had a reputation as a scratch golfer (four holes-in-one!) and an excellent pool player. He was honored by the *Seattle Times* in their special feature entitled, "101 Sports Icons," which appeared in the paper on June 23, 2002. The article listed the greatest athletes in Seattle sports history by uniform number, and Fielder was named as the best player ever to don number "7", beating out other local notables such as Brock Huard, quarterback for the University of Washington, and Jo Jo White, a member of the Seattle Rainiers baseball club.

SEVEN

The Breakers
and Thunderbirds
(1977–Present)

The loss of the Totems in the spring of 1975 left Seattle without hockey, but not for long. The Kamloops Chiefs of the junior Western Hockey League (WHL) moved to the city to begin play as the Seattle Breakers for the 1977–1978 season. The WHL was, and still is, designated a major junior league open to players twenty years old and younger. Originally the minimum age for players was set at fourteen, but was increased to sixteen during the mid-1980s.

The team was known as the Breakers during the eight seasons from 1977 to 1985, and though some good players came through Seattle during that period the team as a whole was not particularly successful, with only two winning seasons and two playoff series wins. What they lacked in success they made up for in colorful anecdotes. During 1981–1982 the team was dubbed "Sangster's Gangsters" after coach Jack Sangster and their rough-and-tumble style of play which resulted in thirteen players receiving 100 or more penalty minutes during the season, led by Mitch Wilson with 436. The following season owner John Hamilton engineered one of the most unique trades in hockey history when he sent the rights to University of Denver forward Tom Martin to the Victoria Cougars for their team bus. Hamilton later said it was one of the best deals he ever made.

A number of excellent players suited up for the Breakers during this period. Ryan Walter was the league MVP in his only season with the club in 1977–1978, before moving on to a long NHL career. Other former Breakers who went on to the NHL include Tim Hunter, Ken Daneyko, Brent Severyn, John Kordic and Jamie Huscroft. Even with some talented teams, the Breakers were not a good draw with crowds generally averaging less than 2,000 fans per game in the Civic Arena.

The franchise got a face-lift in the fall of 1985, changing its name to the Thunderbirds. The name and logo were new, but the results on the ice were not as the club continued its run of losing seasons. It wasn't until the late 1980s that the team finally came together, built around star center Glen Goodall. Goodall joined the Breakers as a 14 year old in 1984–1985 and quickly developed into the team's top offensive threat. The additions of Lindsay Vallis and Victor Gervais gave the team a more balanced attack, and after a successful 1988–1989 season the Thunderbirds were on the verge of a something big. The final piece of the puzzle was added when a 17-year-old forward from Czechoslovakia named Petr Nedved snuck away from his team and defected to Canada following a midget hockey tournament in Calgary. The Thunderbirds drafted Nedved and he joined the club for the 1989–1990 season, scoring 65 goals and 145 points as the team powered to a 52-17-3 record. Nedved wasn't the only star—Goodall was second in the league in scoring with 76 goals and 163 points while Gervais was third with 64 goals and 160 points. The team was an astounding 33-2-1 at home and played a number of sold-out games in the 12,000-seat Coliseum. They won in the first round of the playoffs before falling to the Kamloops Blazers in the division finals. It was Goodall's last year in Seattle, and over the course of six seasons he re-wrote the junior WHL record book by setting all-time marks for games played (399), goals scored (262) and points (573). His number "10" was retired by the Thunderbirds, making Goodall the only player in Seattle hockey history to receive that honor.

The newfound success, especially the large crowds being drawn to the Coliseum, helped Seattle earn the selection as the host city for the 1992 Memorial Cup, a round robin post-season tournament made up of the champions of the three major junior leagues (WHL, Ontario Hockey League and Quebec Major Junior Hockey League) as well as the team from the host city. The Thunderbirds struggled early in the season, but made a number of trades to strengthen the club in anticipation of the tournament. Despite finishing the season slightly under .500 (33-34-5), they made a good showing in the playoffs, making it to the division finals before bowing out to the eventual WHL and Memorial Cup champion Kamloops Blazers.

The club's next big season was in 1996–1997. Led by 17-year-old sensation Patrick Marleau, the Thunderbirds finished second in the Western Division with a 41-27-4 record. They made it all the way to the WHL finals, where they were swept by the Letbridge Hurricanes in four games. Marleau still had three years of eligibility left and the future looked bright for Seattle. When he was selected by the San Jose Sharks with the second overall pick in the 1997 NHL Entry Draft, it was assumed that he would go to training camp and then return to the Thunderbirds for the 1997–1998 season. Unfortunately for Seattle fans Marleau made such a good showing during the preseason that the Sharks decided to keep him on the NHL roster and he never returned to the juniors.

During the team's 27 seasons in Seattle (1977–2004), twelve players have been selected in the first round of the NHL Entry Draft and dozens of former Breakers and Thunderbirds have played in the NHL. Part of the appeal of junior hockey is that fans are able to watch the stars of the future develop as players, and Thunderbirds fans have been fortunate enough to see some great ones come through Seattle. In addition to providing a positive environment for young players, in recent years the team has also been heavily involved in local charities through the Microsoft Hockey Challenge, a weekend of events and hockey games raising money for Ronald McDonald House. With a new local ownership group purchasing the team prior to the 2002–2003 season, the future of the franchise and hockey in Seattle looks to be in good hands.

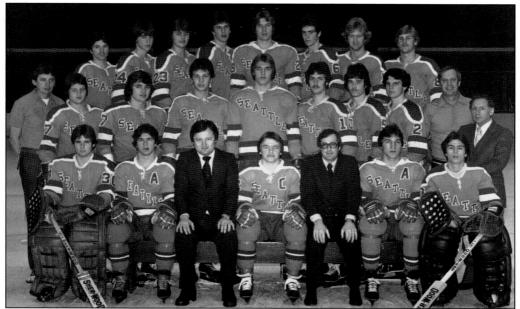

Despite their poor performance on the ice, the Breakers often had excellent players on the roster. The 1979–1980 club finished with a 29-41-2 record but included four players who eventually made it to the NHL: Wayne Van Dorp, Joe Ward, Tim Hunter and Glenn Anderson. Hunter (front row, second from right) appeared in over 800 NHL games and won a Stanley Cup with Calgary in 1989.

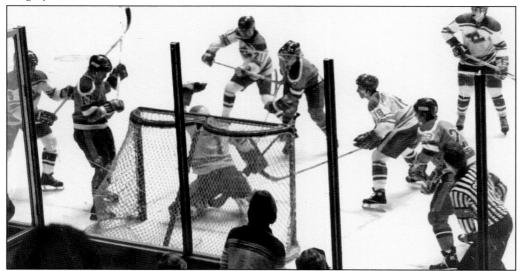

On December 12, 1979, the Breakers faced off against Moscow Spartak of the Russian major league. Spartak was a professional team with players considerably older than the junior league Breakers. To even the odds a little an entire line from the Portland Winter Hawks suited up with the Seattle squad for the game. Tom Stanger's goal (Stanger is wearing No. 7) cut the Russian lead to two late in the second period, but that was as close as the Breakers got, eventually losing by a score of 7-4. The Russian coach, Igor Dmitriv, stated after the game that the Breakers were the best team the Soviets faced on their tour.

Seattle Breakers Hockey Club

For eight seasons between 1977 and 1985 the Breakers struggled in Seattle. Though the club had only two winning seasons and never finished higher than third in the divisional standings, a number of highly touted players came through the organization. Twenty-one Breakers were selected in the NHL Entry Draft, most notably Ryan Walter, Ken Daneyko, Glenn Anderson and Tim Hunter, all of whom enjoyed long NHL careers.

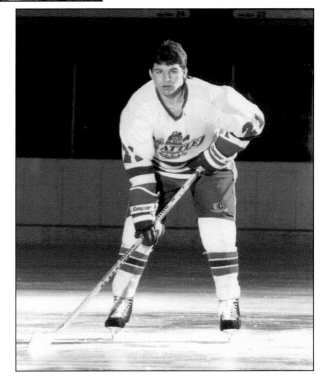

Darcy Simon averaged 239 penalty minutes per season during his three years with the Thunderbirds from 1987 to 1990. The defenseman was one of the toughest players in the league and wasn't afraid to drop the gloves. The team's record improved every season he was on the roster, culminating with a franchise best 52-17-3 finish in 1989–1990. (Courtesy of the Seattle Thunderbirds.)

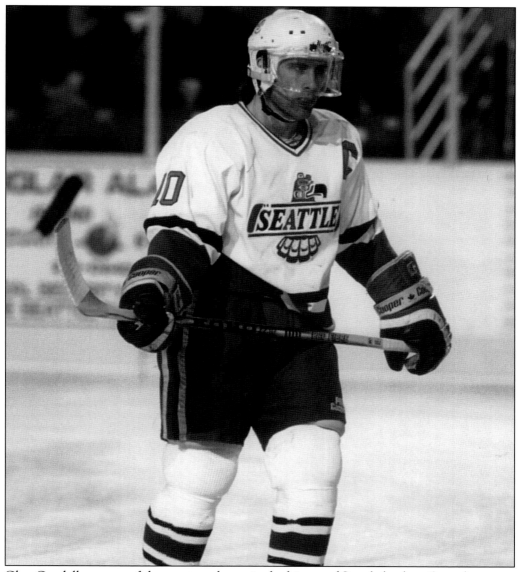

Glen Goodall was one of the greatest players in the history of Seattle hockey. Over the course of six seasons with the Breakers and Thunderbirds (1984–1990) he set league records in games played (399), goals (262) and points (573). The center began his career in Seattle at the age of fourteen during the 1984–1985 season, the last season players that young were allowed in the league, and his longevity assures that many of his records will never be broken. During the Thunderbirds' great 1989–1990 season, Goodall was second in the WHL in scoring with 76 goals and 163 total points, earning league MVP honors. At the end of that season the organization held "Glen Goodall Night" in Seattle, retiring his number "10" following the game. He is the only Seattle hockey player to have his number retired by his team. Though a top scorer in the juniors, Goodall wasn't selected until the tenth round of the 1988 NHL Entry Draft. Most experts agree that his small size (5'8", 170lbs) prevented him from making it to the NHL, though he had a long and successful minor league career including 10 seasons in Germany. (Courtesy of the Seattle Thunderbirds.)

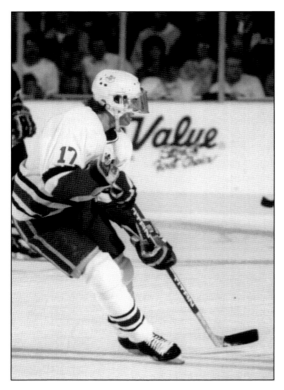

Seventeen-year-old Petr Nedved defected from the national junior team of his native Czechoslovakia following a tournament in Calgary in December of 1988. He was granted refugee status in Canada and allowed to stay in the country. The Thunderbirds obtained his rights and he joined the team for the 1989–1990 season, setting the WHL afire with 65 goals and 145 points as the league's Rookie of the Year. Following his only season in Seattle, the Vancouver Canucks selected him second overall in the 1990 NHL Entry Draft. He made the Canucks roster that fall and went on to a long and productive NHL career. (Courtesy of the Seattle Thunderbirds.)

Brent Bilodeau (left) was a dominant defenseman for the Thunderbirds from 1989 to 1991. At 6-foot-4, 230 pounds, Bilodeau was one of the biggest and most physical players in the league. He was the first round draft pick of the Montreal Canadiens in 1991. Curt Kamp (right) was the trainer of the Breakers and Thunderbirds for seventeen seasons before retiring in 2003. (Courtesy of the Seattle Thunderbirds.)

Turner Stevenson possessed that rare combination of size and skill, averaging 25 goals and 220 penalty minutes per season during his four year career in Seattle (1988–1992). The Thunderbirds won 160 games during that period, the best consecutive four-year total in franchise history. Stevenson was selected in the first round of the NHL Entry Draft by the Montreal Canadiens and went on to a long NHL career, winning the Stanley Cup with New Jersey in 2000 and 2003. (Courtesy of the Seattle Thunderbirds.)

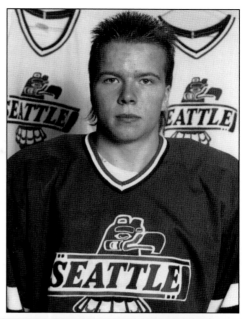

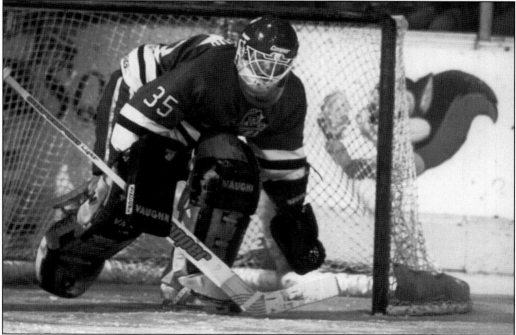

Goaltender Chris Osgood was a late season acquisition by the Thunderbirds in 1991–1992, one of a number of players picked up to strengthen the team for the upcoming Memorial Cup tournament in Seattle. Osgood went 12-7-1 down the stretch, including a 5-0 shutout in a brawl filled game with the league leading Prince Albert Raiders. In the playoffs he had a 9-6 record as the Thunderbirds made it to the Western Division finals, where they were eliminated by the Kamloops Blazers. He has had a long and successful NHL career, winning the Stanley Cup with Detroit in 1997 and 1998. (Courtesy of the Seattle Thunderbirds.)

MOLSON-*Cooper* MEMORIAL CUP SEATTLE '92

MOLSON Ⓜ Cooper

Seattle was selected as the host city for the 1992 Memorial Cup, a round-robin tournament featuring the league champions from the three major junior leagues (WHL, Ontario Hockey League and Quebec Major Junior Hockey League) as well as the team from the host city. After a slow start to the season, the Thunderbirds made a number of trades to strengthen the club, acquiring a number of veteran players including goaltender Chris Osgood, forwards Blake Knox and Duane Maruschak, and defensemen Kurt Seher and Joel Dyck. Despite finishing the season one game under .500, the club set a WHL attendance record by drawing 240,428 fans, including an average of almost 9,500 fans per game at the Coliseum (the team also played games in the Civic Arena). Unfortunately the fans didn't come out in the same numbers during the tournament, which was forced to move a number of games from the Coliseum to the smaller Arena due to scheduling conflicts with the NBA's Seattle Supersonics. The Thunderbirds made it to the semi-finals against Kamloops where they were defeated 8-3 in front of a small crowd of just over 5,000 fans. Kamloops won the tournament the following day with a 5-4 win over Sault Ste. Marie.

A bruising defenseman from Humboldt, Saskatchewan, Brendan Witt played three seasons in Seattle between 1991 and 1994. A physical presence on the ice, Witt averaged 230 penalty minutes per season and was awarded the Bill Hunter Trophy as the WHL's top defenseman in 1993–1994. In addition to being a solid defenseman and a good fighter, Witt was also a tremendous open ice checker known for stopping on a dime to drop his shoulder into a rushing forward. He sat out his final WHL season in a contract dispute with the Washington Capitals, refusing to return to Seattle for his last year of eligibility. (Courtesy of the Seattle Thunderbirds.)

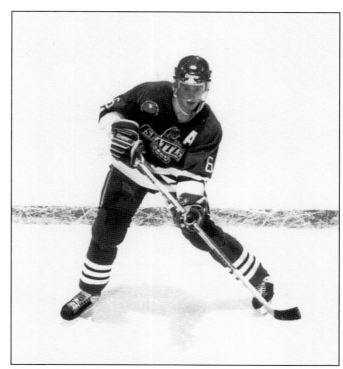

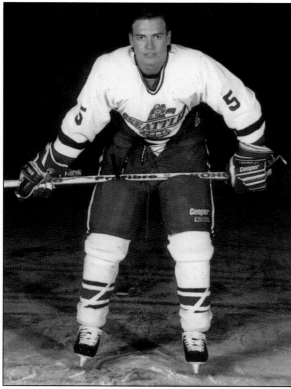

Brett Duncan (shown here) and Brendan Witt formed the most feared blueline in the WHL from 1992 to 1994. Duncan averaged 313 penalty minutes per season and was known as one of the top fighters in the league, using his powerful left hand to surprise opponents early in bouts. Though he was skilled with his fists, Duncan was also a solid defenseman who could play a disciplined game when necessary. (Courtesy of the Seattle Thunderbirds)

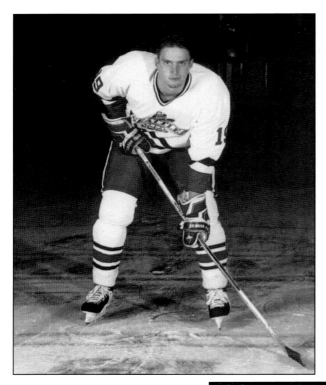

When Chris Wells arrived in Seattle to start the 1991–1992 season, the 15-year-old center was already 6-feet, 6-inches tall. It took him a few seasons to grow into his tall frame, but once he did Wells became one of the league's most dangerous players in front of the net, using his size and long reach to deflect pucks and pick up rebounds. In his final season in Seattle (1994-95), Wells was named team captain and led the club in scoring with 45 goals and 108 points. His size assured him an opportunity in the NHL, and while he played in 195 games with Florida and Pittsburgh he only scored nine career goals. (Courtesy of the Seattle Thunderbirds.)

Chris Herperger was acquired in a trade with Swift Current early in the 1992–1993 season. An incredibly gifted forward, he holds the franchise single-season (12) and career (17) records for goals scored in the playoffs. In addition to his scoring touch, Herperger was also great in the face-off circle and was consistently used to take key draws for the team. (Courtesy of the Seattle Thunderbirds.)

Doug Bonner was the first African-American to play in a regular season game for a Seattle team. A native of nearby Tacoma, Bonner appeared in 176 games between the pipes for the Thunderbirds from 1992 to 1996, the second most in franchise history. Extremely athletic, he was known for both his flashy saves as well as for giving up some easy goals. Despite two good years as a starter, playoff success eluded Bonner and his postseason record was a disappointing 1-7. (Photo by Harry Conrad.)

Patrick Marleau was arguably the most talented junior leaguer in Seattle hockey history. He was the Thunderbirds' top scorer as a 16-year-old rookie in 1995–1996, and the following season his 51 goals and 125 points led the club to a second place finish in the Western Division. He added another seven goals and 23 points in the playoff as the Thunderbirds made their first (and so far only) appearance in the WHL finals in 1997, where they fell to the Lethbridge Hurricanes. A first round draft pick of the San Jose Sharks, he became one of the youngest players in NHL history when he played his first game in the league just after his 18th birthday. (Photo by Harry Conrad.)

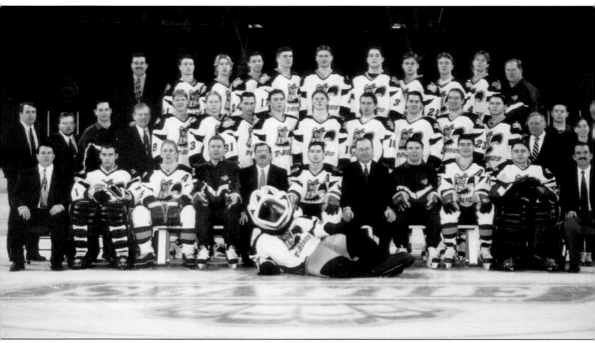

The 1996–1997 Seattle Thunderbirds were the most successful team in franchise history. Led by scrappy captain Tyler Willis (302 PIM) and high-scoring Patrick Marleau (51 goals, 125 points), they finished the season with a 41-27-4 record and made it to the WHL finals. They were swept in the finals by Lethbridge, but every game in the series was close and the two contests in Seattle were some of the best hockey ever seen in the city. Expectations for an even better team the following year were dashed when Marleau made the roster of the San Jose Sharks and didn't return to Seattle. (Courtesy of the Seattle Thunderbirds.)

Oleg Saprykin arrived from Russia for the start of the 1998–1999 season and immediately mesmerized Seattle fans with his incredible speed and stick-handling. His goals-per-game ratio of one goal per 1.48 games (77 goals, 114 games played) is the second best in franchise history for players appearing in more than 100 contests, behind only Errol Rausse (one goal per 1.12 games). A gifted offensive player, he was selected in the first round of the 1999 NHL Entry Draft by the Calgary Flames. (Photo by Harry Conrad.)

Mark Parrish (right) joined the Thunderbirds as a 20 year old for the 1997–1998 season after two successful years of college hockey with St. Cloud State. During his only season in Seattle he was named team captain, scoring 54 goals in 54 games to lead the club. His patented deke to the backhand on breakaways was one of the most effective moves ever seen in Seattle, leading to a number of goals. He is shown here receiving an award from Thunderbirds coach Don Nachbauer (left). (Photo by Harry Conrad.)

Goaltender Cody Rudkowsky holds the franchise record for most career shutouts (8) and is second all-time in wins with 73. He capped off his three-year career in Seattle with an incredible 1998–1999 season during which he went 34-17-10 with seven shutouts, five of which came during a nine game stretch from February 2-20, 1999. Rudkowsky was named both Goaltender of the Year and Player of the Year in the WHL that season. His quickness and his willingness to clear opposing players out of the crease by any means necessary endeared him to Seattle fans who consider him one of the top goalies in club history. (Photo by Harry Conrad)

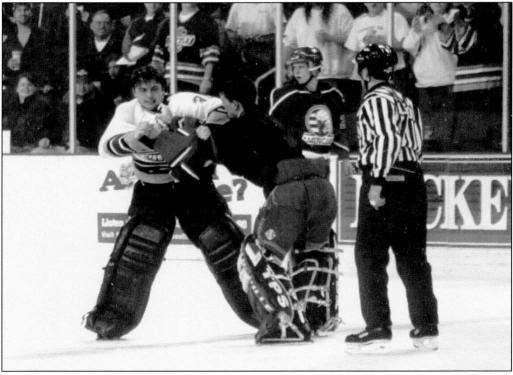

Life in the WHL isn't easy, and sometimes even the goalies have to drop the gloves and go at it. Cody Rudkowsky (left) and Aaron Baker (right) of the Tri-City Americans went toe-to-toe in this memorable bout during the 1998–1999 season, the first time two goaltenders had fought on Seattle ice in over ten years. Rudkowsky won the decision in what was one of the most memorable events in the recent history of hockey in Seattle. (Photo by Harry Conrad.)

The Hockey Challenge—an annual weekend fund raiser for Seattle's Ronald McDonald House—began in 1998 as a friendly charitable challenge between departments within Microsoft. In the first six years it blossomed from its pass-the-hat inception into a $2.5 million event drawing celebrity participation from the likes of Wayne Gretzky and Pat LaFontaine to Kiefer Sutherland and Tom Arnold. Cool Bird (mascot of the Seattle Thunderbirds) lands here for a quick photo with Ronald McDonald, participating corporate executives, the planning committee and 14 of the most important reasons for the event—the kids from the House. In 2003, in part due to the success of the Challenge, the Seattle Ronald McDonald House expanded to allow it to serve over 80 families nightly. (Courtesy of the Seattle Thunderbirds.)

Pat Smith's career has run the hockey gamut in Seattle. He played three seasons with the Breakers from 1980 to 1983, later returning to the organization as an assistant coach with the Thunderbirds from 1988 to 1991. A successful real estate agent, Pat became part of the new ownership group that purchased the Thunderbirds during the summer of 2002. (Courtesy of the Seattle Thunderbirds)

Bibliographical Essay

A wide range of sources were used in researching this book. For purely historical information I relied heavily on articles from the *Seattle Daily Times*, the *Seattle Times* and the *Seattle Post–Intelligencer*. Countless hours were spent reviewing these newspapers on microfilm at the Seattle Public Library, and those articles filled in a lot of holes especially with regards to player biographies from the earliest days of hockey in Seattle. Another valuable source for player information is game-night programs produced by the teams, which often contain biographical material as well as information on specific games or events.

While baseball has done an excellent job at refining and correcting historical statistical data, the same cannot be said for hockey. Discrepancies between sources are common, especially in the earliest periods and in the minor leagues. As a result a number of sources were utilized and compared to arrive at the most accurate information possible. Media guides published by both the professional and junior Western Hockey League were utilized, as was *Total Hockey, Second Edition* (Kingston, NY, 2000). *Total Hockey*, despite a number of small errors, is by far the most complete and accurate source of hockey statistics available anywhere. The editors are very receptive to corrections, and hopefully an updated and even more accurate third edition will be produced.

Gathering information from the earliest days of Seattle hockey was extremely difficult, but a handful of excellent books were of immense help. *The Patricks—Hockey's Royal Family* (Garden City, NY, 1980) by Eric Whitehead is one of the best works on the history of the PCHA; Morey Holzman and Joseph Nieforth's *Deceptions and Doublecross* (Toronto, Ont, 2002) delves deeply into the war between the NHA and PCHA; Charles L. Coleman's *The Trail of the Stanley Cup, Volume One* (Debuque, IA, 1966) is unquestionably the best source on the early days of hockey, especially the Stanley Cup finals; *Wherever You May Be . . .* (Wilsonville, OR, 1999) by Bill Schonely provided a behind-the-scenes look at the Americans and Totems in the 1950s and 60s. Two essays were also very helpful: "The Pacific Coast Hockey Association" by Thomas D. Picard, printed in *Total Hockey* (New York, NY, 1998); also "The Pacific Coast Hockey Association" by Ron Boileau and Philip Wolf, printed in the previously cited *Total Hockey, Second Edition*.

The Internet has proven to be a valuable tool for researchers in recent years, and three web sites played an important role in this work. Ralph Slate's "The Internet Hockey Database" (www.hockeydb.com) is the best source for hockey statistics on the Net today. Also useful was Louis Chirillo's "The Unofficial Seattle Totems Hockey Club Website" (www.seattletotems.org) and information included on the author's own site, "The Seattle Hockey Homepage" (www.seattlehockey.net).